IMAGES
of America

AUGUSTA COUNTY

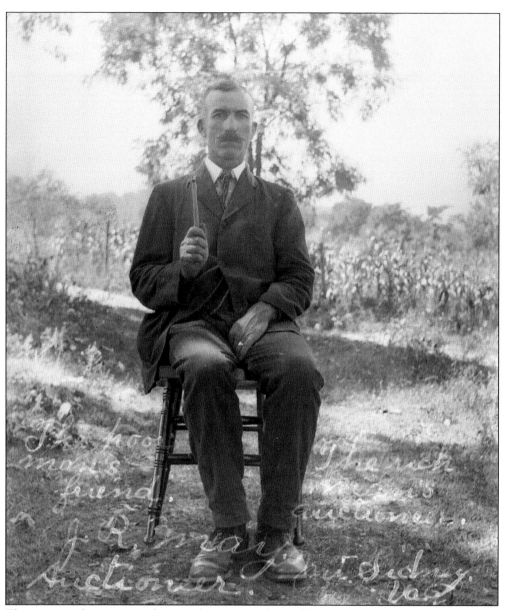

The notation that amateur photographer Henry Clay Coffman put on this photograph reads as follows: "The poor man's friend. The rich man's auctioneer. J.R. May. Auctioneer. Mt. Sidney, Va." The photograph of May, gavel in hand, was taken about 1900. This book would not have been possible without people like Coffman who felt the need to document the everyday life around them. Thank goodness for their curiosity. (Courtesy Augusta County Historical Society, Coffman Collection.)

ON THE COVER: Home Demonstration clubs filled an important niche in the lives of Augusta County farm women, particularly during the Depression. Home Demonstration agent Ruth Jamison promoted home furnishings projects to the rural women of the county and encouraged them to recycle antique furniture rather than buy "cheap" new pieces. In this 1931 photograph, Mint Spring and Spottswood club members watch as a chair receives a new seat. (Courtesy Ann McCleary.)

IMAGES
of America

AUGUSTA COUNTY

Nancy T. Sorrells on behalf of
the Augusta County Historical Society

ARCADIA
PUBLISHING

Copyright © 2014 by Nancy T. Sorrells on behalf of the Augusta County Historical Society
ISBN 978-1-4671-2108-8

Published by Arcadia Publishing
Charleston, South Carolina

Printed in the United States of America

Library of Congress Control Number: 2013945930

For all general information, please contact Arcadia Publishing:
Telephone 843-853-2070
Fax 843-853-0044
E-mail sales@arcadiapublishing.com
For customer service and orders:
Toll-Free 1-888-313-2665

Visit us on the Internet at www.arcadiapublishing.com

*To Augusta County Historical Society's founding members,
who, in 1964, realized that our rich heritage deserved an
organization dedicated to "Preserving the Past for the Future"*

CONTENTS

ACKNOWLEDGMENTS

I would gratefully like to acknowledge the following people, who made this book possible: Augusta County Historical Society (ACHS) board member Sue Simmons, who helped with much of the writing and organization of the book; ACHS office manager Betty Lewandowski and ACHS archivist Dr. Ken Keller, who know their way around the historical society's archives like no one else and were able to locate some amazing photographs; and interns Brodie Chittum and Annaleah Morse, who helped research and write many of the captions. In addition, I would like to thank Mary Kay Van Hooser, who skillfully unframed and reframed photographs that had to be scanned.

Although the ACHS archives provided a treasure trove of photographs of all sorts, of particular help were two collections, the Coffman Collection and the Augusta Country (AC) Collection, both of which bring to light everyday images depicting a society long past.

I would also like to thank the following individuals, who allowed their valuable images to be shared for this project: Mary Altizer, the Augusta County Sheriff's Office, Kimberly Lucas Berry, John Brake, Walter Brown, Bill Brubeck, Rudolph Bumgardner III, the Camera Heritage Museum, the Coffman family, Virginia Davis, Janet and Earl Downs, Catherine Evans, the Fridley family, Chris Furr, Dr. Clarence Geier of the James Madison University Department of Sociology and Anthropology (JMUDSA), Joe Glovier, Good Shepherd Episcopal Church, Betty Jo Hamilton of *Augusta Country*, William Arlen Hanger, Owen Harner, Bud Hoffman, Julie and Leroy Kent, Janet Lembke, Lot's Wife Publishing, Finley Lotts, David McCaskey, Harry R. McCray, L.B. McCray, Mike McCray, Elaine Moran, Old Providence Associate Reformed Presbyterian Church, Dorothy Lee Rosen, Gary Rosen, the R.R. Smith Center for History and Art, the Sorrells family, the Stonewall Jackson House (Virginia Military Institute Museums), Dorothy Thomas, Tinkling Spring Presbyterian Church, the United States Department of Agriculture, the John Wayland family, the Weyers Cave Fire Company, and the Woodrow Wilson Rehabilitation Center Foundation.

INTRODUCTION

When Augusta County was formed from Orange County, Virginia, in 1738, it was America's "Wild West," stretching to the Mississippi River and the Great Lakes. It even included the territory that became the city of Pittsburgh, Pennsylvania. As Virginia was still a British colony, the inspiration for the name of the new county came from the British royal family and Princess Augusta, the mother of King George III of Revolutionary War fame. For seven years, until the population grew large enough, Augusta's records were kept in Orange. In 1745, Augusta elected a sheriff, a vestry, county court justices, and a clerk of the court. A county courthouse was built on the same site in Staunton where the current courthouse stands today. The county's records have been kept continuously at the courthouse since 1745. Staunton, originally called Beverley's Mill Place, has always been the county seat. The city was named for Lady Rebecca Staunton, the wife of Colonial governor William Gooch, who encouraged the settlement of the valley by Scotch-Irish and German immigrants by providing to them a measure of religious toleration.

Many early settlers took up land on the 112,000-acre tract that the Colonial government granted to William Beverley. As people began to settle in the more western areas, new counties were cut off from Augusta, beginning with Botetourt County in 1769, and followed by Rockingham and Rockbridge Counties in 1778. Today's more moderately sized county lies nestled between the Blue Ridge and Allegheny Mountains in the heart of the Shenandoah Valley. Virginia's second-largest county, at just under 1,000 square miles, has witnessed history ranging from frontier clashes to Civil War battles. Daniel Boone, Thomas Jefferson, and Robert E. Lee slept here, Pres. Dwight Eisenhower's mother, Ida Stover, was born here, and folk artist Grandma Moses farmed here with her husband.

The main road through the county, once known as the Warrior's Path, the Great Wagon Road, and the Valley Pike, has been trod by Native Americans, settlers, travelers, and warring armies. The streams of Scotch-Irish, German, English, and African American people who put down roots here turned the lush limestone valley into the grain producing capital of the nation and created the county's two leading industries, milling and distilling. Today, the main crops are corn, hay, and soybeans, and there are plenty of cattle and sheep in the fields—the county ranks second in the state for agricultural production. In the foothills on either side of the valley, mountainsides that were denuded from timbering a century ago have been transformed into vast acreages that include the George Washington National Forest and Shenandoah National Park.

As the Augusta County Historical Society members involved in this project began collecting and scanning the images in this book, they realized the challenge of coherently presenting the many facets of Augusta County life. Proper attention needed to be paid to men, women, children, and, yes, even the farm animals and pets who helped make Augusta County unique. Some of the people included in the book are legendary, such as John Lewis and Grandma Moses, but many of the names that would go with the work-worn faces on these pages have been lost to the annals of time. And, yes, there are even two famous animals in the book: a pig and a horse. More often than not, however, the droves of cattle and hogs that passed by on the turnpikes and through villages were destined for the dinner tables, not the newspaper columns.

After great consternation and discussion of how to present as wide a range of topics as possible, 10 chapters were developed to feature Augusta County life. Please realize that these are not all encompassing; they are designed to provide a taste of the past and of times when the main mode of transportation had four legs and the big city was Staunton. Images of strip mining, floods, and the twisted metal of airplanes, trains, and automobiles serve as reminders that everything was not better in the "good old days." However, photographs showing the joy of a little boy holding up his baseball mitt, girls building a snowman, and a family gathering that included more than a few folks holding musical instruments show that sometimes those really were different and joyful times.

Each chapter stands as a small history lesson about Augusta County, from its people to its schools, churches, and buildings. But it is not just a history lesson for Augusta, because the county never existed in an unconnected vacuum. The first settlement of the county was driven by global forces that eventually erupted into the French and Indian War, the flour grown here was used by the California '49ers in their gold rush camps, and the engineering marvel that brought the train underneath a mountain into the valley was dug by Irish workers who came here to escape the potato famine.

This book is also a reminder that history is not always pretty. The harsh reality of history in Augusta is that from its beginning until 1865, most African Americans here were held in bondage. And, although very few of the names of those men, women, and children survive, their work provided the framework on which the society was built. In the years after the Civil War, they struggled for equality here just as they did throughout the South.

Finally, it is appropriate that this project, designed to showcase Augusta's rich heritage, comes along at the right time to help celebrate the 50th anniversary of the Augusta County Historical Society. In 1964, a group of citizens founded the society in order to study, collect, preserve, publish, educate, and promote the history of Augusta County and its communities. Many of the photographs showcased here would have been lost to time if those charter members had not been able to simultaneously look at the past and think about the future. The society has selected the best images from its rich collection while also working with private individuals and groups to discover amazing photographs of long-forgotten schools, churches, family gatherings, industries, and village life to feature a wide spectrum of faces and places from the county's storied past.

One of the tasks of Augusta County's government officials in the 1700s was to create a seal so that legal documents such as deeds and wills could have a wax symbol of authority. The basic design of that seal has remained the same ever since. It features a verdant agricultural scene of a young lad leaning against a tree and playing a flute to some cows that appear to be listening. The Latin motto around the edge of the seal reads, "Redeant in Aurum Secula Priscum," which loosely translates to, "Let us return to the Golden Ages." We invite you to do just that as you turn the pages of this book.

One

TOWNS AND VILLAGES

Augusta County was created in 1738. When the government got underway seven years later, the necessity of designating a county seat arose. Beverley's Mill Place, soon called Staunton, became that spot, and a courthouse, a parish church, and a jail were built. Today, Staunton is one of two independent cities within the county. The other is Waynesboro, which began as the village of Teasville and became an independent city in the 1900s after absorbing Basic City.

However, a number of other villages have grown and thrived in the 250 years since Augusta's founding. Most sprouted along transportation corridors such as turnpikes or railroads or around industries such as mills or tanneries. Many small communities had multiple names because the depot had one name and the post office another. One example is the community along the Norfolk & Western Railroad just east of Greenville. The railroad depot was called Cold Springs, but the post office was Ellard. The village of Spring Hill was also known as Long Glade because of its post office.

After the creation of Staunton, Greenville, located along the Great Wagon Road, was the next village platted, in 1794. This thriving community sported a mill and a woolen factory, several general stores, a hatter, two tanyards, a railroad depot, and even a newspaper. In the 1930s, a flood destroyed a bridge and Greenville did not have money for repairs. It then unincorporated and threw itself on the mercy of the county government.

Throughout the county, the automobile changed everything in the 1900s, and villages lost business to commercial centers like Staunton and Waynesboro. Today, the only incorporated town is Craigsville. Although not the thriving community it once was when several industries were operating there, the town still has its own council and police force. Other former villages such as Sampson, Burketown, Newport, Madrid, and Swoope have long lost their former glory. However, two entire villages, Middlebrook and Mount Sidney, are listed in the National Register of Historic Places—reminders of a time now past when the village was the center of public life.

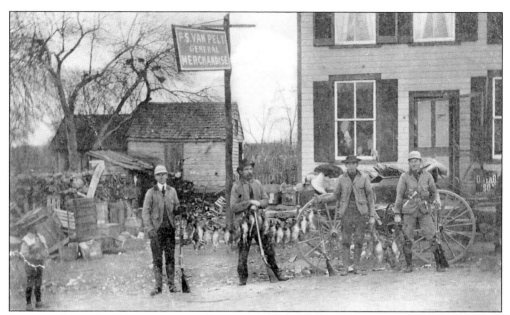

A group of waterfowl hunters poses in front of F.S. Van Pelt General Merchandise in Burketown after a successful day in the field. The village is located on Route 11 on the Augusta-Rockingham county line. (Courtesy ACHS, Coffman Collection.)

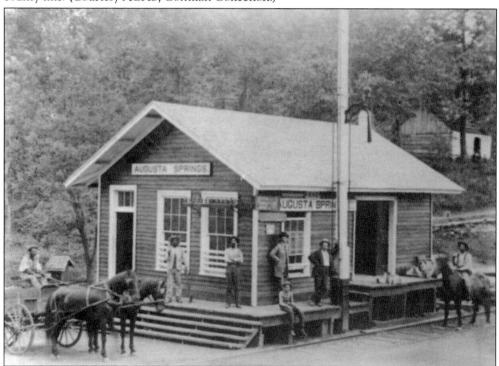

The railroad that eventually became known as the Chesapeake & Ohio came through Augusta Springs in the 1850s. This is what the train depot looked like in the late 1800s, when many passengers arrived there in order to spend time at the resort springs just across the road. (Courtesy Fridley family.)

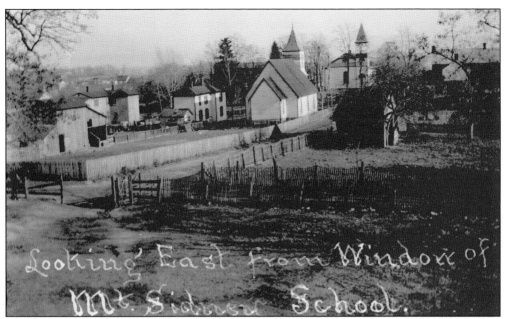

The northern Augusta County turnpike town of Mount Sidney is seen here from the school. The view, looking east, affords a rare view of the main street backyard on the west side of what was once the Great Wagon Road, then the Valley Pike, and is now Route 11. Although a tavern and a handful of businesses predated the village, the town was platted in 1826. The main street consisted of 41 long, narrow lots. (Courtesy ACHS, Coffman Collection.)

A farm wagon pulled by a team of workhorses stands in front of the Mowry house in New Hope in 1905. The dog lying on the front seat proves the timelessness of the question, "Want to go for a ride?" (Courtesy Owen Harner.)

This photograph shows a portion of the New Hope Road in the mid-to-late 1800s. On the right is the Dickerson-Fretwell Tavern. Built in 1818, the tavern served as a public house and stagecoach stop. It was turned into a hospital for wounded Confederate soldiers after the Battle of Piedmont

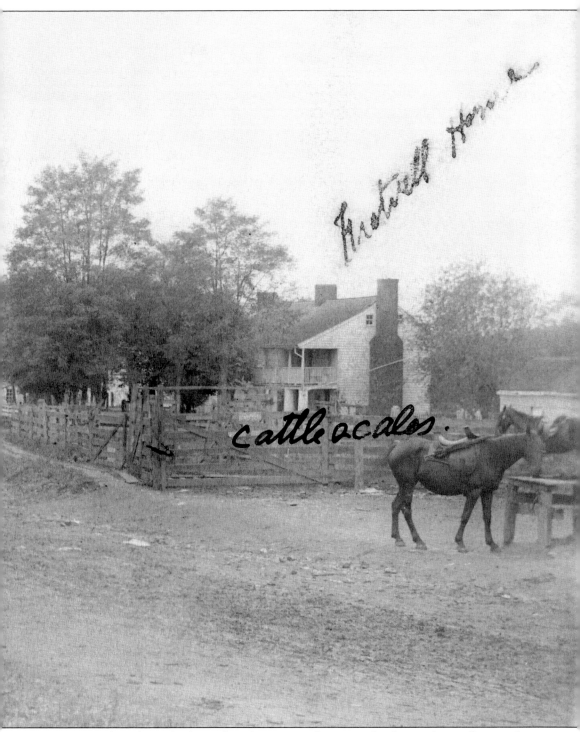

Hartwell House

cattle scales.

in 1864. A cattle scales is also located on the main road, proving that livestock as well as people and wheeled vehicles used the roadway through the village. (Courtesy Owen Harner.)

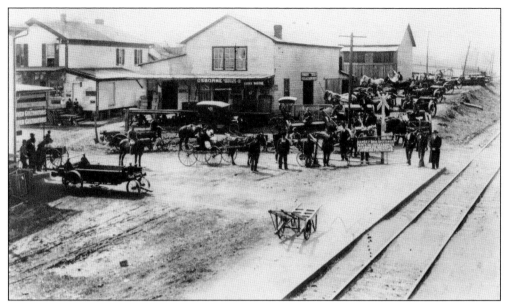

Spottswood, in southern Augusta County just west of Route 11, was developed in the late 1800s as a village along the Baltimore & Ohio Railroad. Access to the railroad proved invaluable for the thriving farm community. The railroad disappeared before World War II and businesses like the thriving Ramsey Bros. eventually faded away. (Courtesy ACHS.)

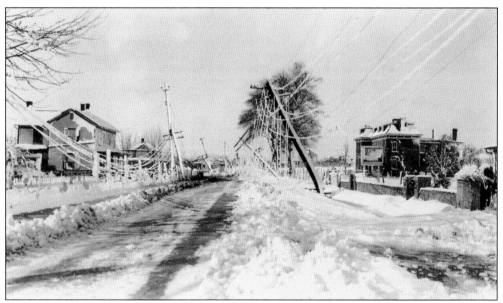

Snow and ice pull down telephone and power lines in the late 1920s or early 1930s on Route 11 in Verona, looking south toward Staunton. Verona is sometimes referred to as Rolla, for the name of the post office and nearby mill. The brick building with the mansard roof on the right was later painted white and became an Esso service station before being torn down. (Courtesy Joe Glovier.)

The village of New Hope owes its existence to the New Hope General Store, seen here in 1954. Northeastern Augusta County was little more than farms and a few churches connected by dirt roads when James M. Stout built the general merchandise store in 1804. The village of New Hope grew from this enterprise. Over the years, the store served as a post office, polling place, and gathering spot, as well as a market and gas station, for the rural community. (Courtesy Owen Harner.)

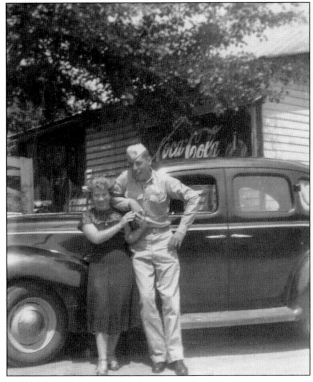

In the summer of 1952, Marybelle Bradley Braman and Keith Fitzgerald pose for the camera in front of H.H. Fitzgerald's store, along the Norfolk & Western railroad tracks in southeastern Augusta County. Although the depot was called Cold Springs, the post office was Ellard. A kaolin processing plant was there as well. The post office and the plant closed in the 1950s. The store closed a few years later and is now a private residence. (Courtesy Elaine Moran.)

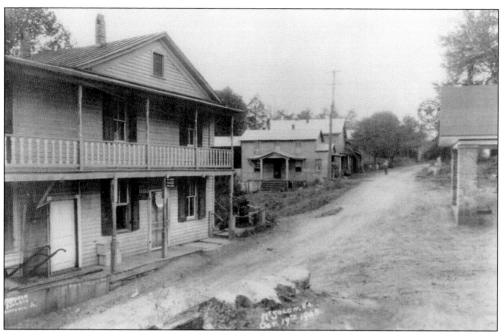

Located in northwestern Augusta County and founded in 1799, the village of Mount Solon started as a log cabin and mill. Other businesses followed, including a distillery, a tanyard, a blacksmith shop, a store, a school, and, later, the Chesapeake & Western Railroad. A fire destroyed most of the town in 1860, and the majority of the buildings in these photographs were built after the fire. Many businesses have left Mount Solon, but the layout of the village streets, seen in these two views, remains virtually unchanged. Today, the town serves as the gateway to Natural Chimneys Park, which offers a variety of camping and outdoor activities and is home to an annual jousting tournament. (Both courtesy Joe Glovier.)

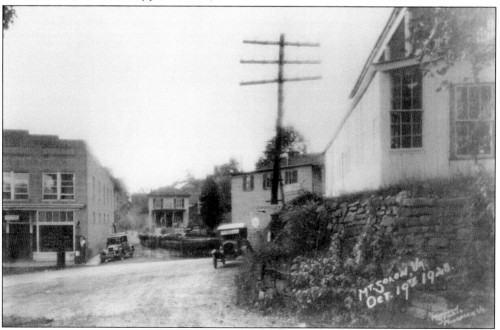

Two boys clown around in front of one of the Middlebrook general stores. Judging from the advertisements for gasoline and tires at the store, the village had clearly entered the automobile age. (Courtesy ACHS, AC Collection.)

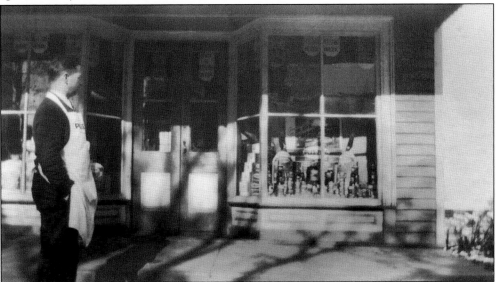

After Staunton, the next town laid out in the county was Greenville, named for Revolutionary War general Nathanael Greene, who led many area residents in battle. Although platted in 1794, the community along the Great Wagon Road had existed for decades. Before the automobile took business to Staunton and Waynesboro, villages featured dozens of commercial establishments, including several general stores. Howe A. Spitler (1918–1980), seen here looking at his window display in 1940, was one such merchant; he was also remembered for giving a haircut when one was needed. (Courtesy John Brake.)

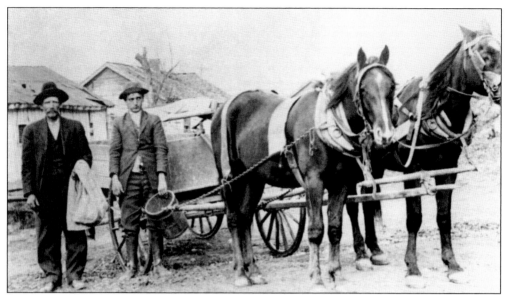

Two men from McKinley prepare to load up their farm wagon with goods to sell over the mountain in the town of Craigsville. Although the mountain road between the village and the town still exists today, it is a rarely traveled byway sometimes best passable with a four-wheel-drive vehicle. A century ago, trade and traffic between the two localities was commonplace. (Courtesy ACHS, AC Collection.)

Allene Reed Arehart and a companion sit ready for a carriage ride in McKinley, located on the dividing ridge between the headwaters of the James and Shenandoah Rivers. The village was once called Gravelly Hill, but the name was changed after the election of Pres. William McKinley, who pushed for the establishment of rural post offices. In 1896, the village received a post office and a new name. (Courtesy ACHS, AC Collection.)

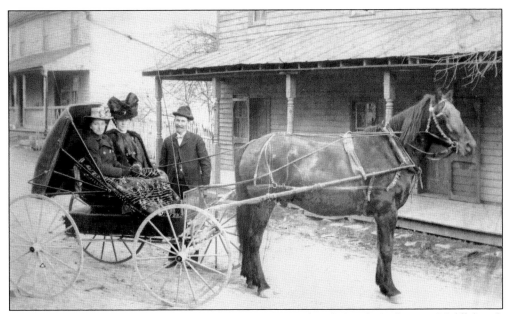

Dora Belle Arehart and Mrs. Jim Bailey sit in a carriage beside Jacob Arehart in Middlebrook about 1900. Platted in 1799, Middlebrook was located on the stagecoach turnpike running from Staunton to Brownsburg. Described as a "hive of industry" in 1887, this farm community was the county's largest village, boasting three coach and wagon builders, three merchants, two physicians, two contractors and builders, a furniture manufacturer, and an undertaker. (Courtesy William Arlen Hanger.)

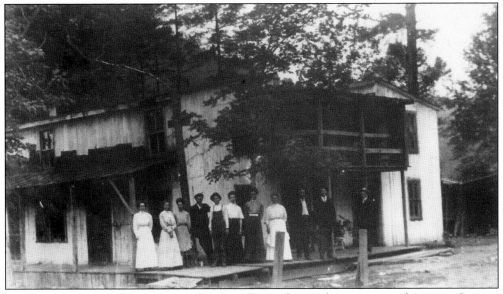

The once-thriving industrial town of Stokesville, in the northwest corner of Augusta County, is now little more than a wide spot in the road. However, from 1901 to 1913, it was a boomtown named for the owner of the Chesapeake & Western Railroad, W.D. Stokes. Timber and some mineral extraction focused around the railroad, and more than 1,500 people lived in the town, where businesses, factories, a school, and the Zirkle Hotel thrived. The hotel, seen here just west of Stokesville proper, was owned by J.P. Houck. (Courtesy JMUDSA, Walter Daggy Collection.)

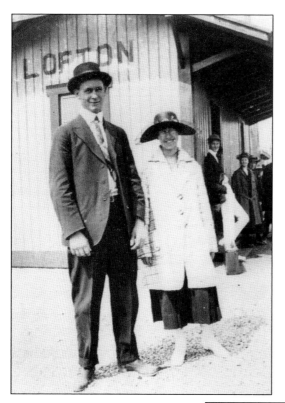

The community of Lofton grew up around the Norfolk & Western Railroad, which ran north to south along the Blue Ridge Mountains. Lofton earned its name because it was the highest-elevation rail stop situated on the headwaters of the north-flowing Shenandoah River and the south-flowing James River. Thus, the line's elevation peaked at the tiny community, and trains headed downhill whether they were traveling north or south. (Courtesy Elaine Moran.)

As the county seat, Staunton has housed Augusta's government buildings since 1745, including, until recently, the jail. When hangings were carried out locally as capital punishment, this gallows existed as well. Even though the last public hanging took place in 1894, capital punishment was highly emotional, as it still is today. In those days, the sheriff had the unwelcome task of also being the executioner. After that last hanging in 1894, the sheriff leaned against the gallows post and wept. (Courtesy Augusta County Sheriff's Office.)

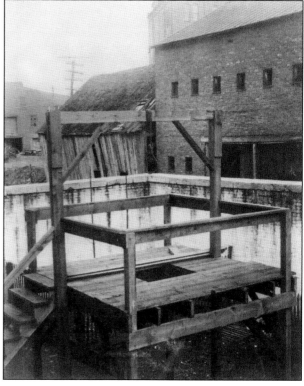

Two

FIELDS AND FARMS

Driven by the need to secure food and fiber for survival, early Augustans were subsistence farmers, but they quickly tapped into commercial markets, first in Philadelphia and then in Richmond. Augusta's farmers have always practiced mixed farming, growing various crops such as corn, oats, and rye, and raising beef, hogs, sheep, and poultry. By the mid-1700s, large droves of cattle and hogs were driven hundreds of miles to distant markets. By the 1800s, large quantities of heavily salted butter were shipped to Richmond and loaded on vessels bound for Caribbean slave plantations.

Throughout its history, Augusta farmers have relied on a cash crop within the mixed farming economy. The earliest cash crop was flax, which was grown by the Scotch-Irish farmers who dominated the county's early settlement and brought textile skills from the old country. In the years before and during the American Revolution, those textile production skills were transferred from flax to another fiber-producing plant, hemp, which was used for making canvas and rope. By the mid-1760s, hemp production averaged 100,000 pounds annually. After the war, farmers returned to growing flax and weaving linen. The perfection of the cotton gin by the early 1800s marginalized textile production, although flax was still grown for linseed oil.

By the early 1800s, wheat for flour and corn and rye for whiskey dominated the agrarian economy, although livestock never waned as an important component. After the Civil War, apple orchards took on an increased importance. By 1900, Augusta led the state in apple production. Migrant African American workers blended with the local workforce during harvest time. The rise of large grocery chains demanding the perfect apple for shipping and fruit orchards in the Pacific Northwest spelled doom for the apple industry by the mid-1900s.

Refrigerated train cars and trucks used to transport large quantities of milk, as well as selective turkey breeding and the move of turkey production from pastures to enclosed buildings changed county agriculture by the 1950s, giving rise to strong dairy and poultry industries.

Today, Augusta County ranks second in the state in agricultural production, while leading Virginia in beef, sheep, and hay production and farm acreage.

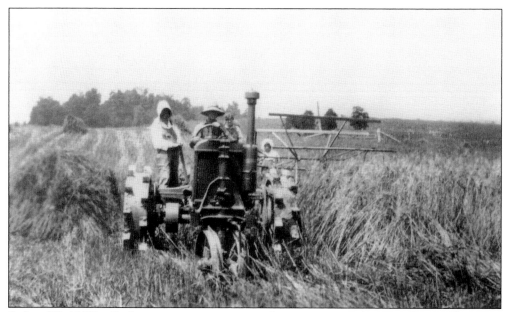

Before World War II, the most important annual activity on an Augusta County farm was harvesting the wheat. In this June 1931 photograph, the whole Hawkins family is involved in bringing in the crop. (Courtesy ACHS, AC Collection.)

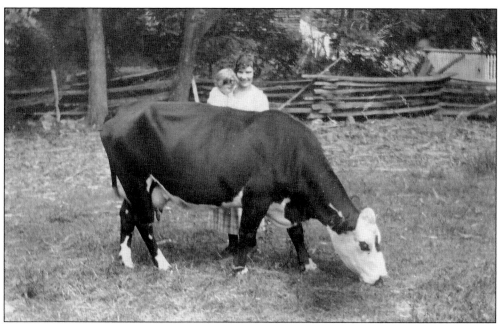

A mother and young child stand behind a peacefully grazing cow, probably the supplier of the family's milk and butter, in western Augusta. Note the split rail fencing behind them and the fancy picket fence around the farmhouse in the right background. (Courtesy Virginia Davis.)

African American farmers were often tenant farmers or farm laborers for white farmers as a result of Jim Crow segregation and economic hardships during the Great Depression. Clarence Jones is seen here cultivating corn on the Driver farm, near Weyers Cave. The Jones family helped the Driver family operate its farm and household, and also owned a small parcel of land near the railroad where they raised a milk cow, chickens, and hogs. Although the Driver family offered Jones a tenant house on the farm, Jones declined, stating the he preferred the independence of owning his own farm. (Courtesy David McCaskey.)

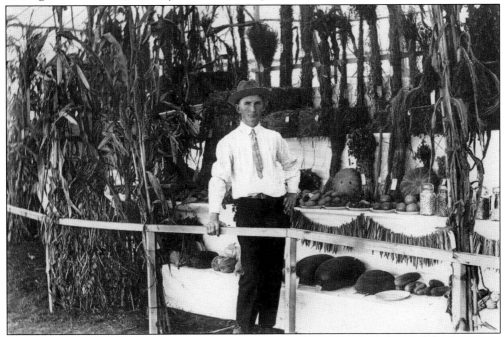

Northern Augusta County farmer Jimmy Bailey stands in front of his first-place exhibit for county agricultural products at the 1916 state fair, held in Staunton. The Bailey farm was on the Middle River near Fort Defiance. (Courtesy Dorothy Lee Rosen.)

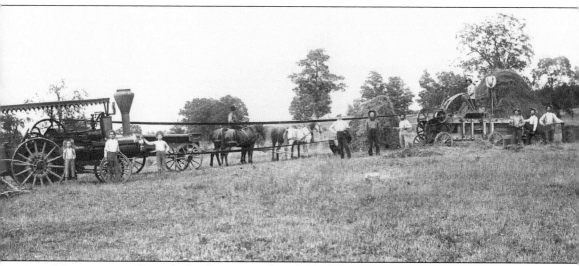

Hay was originally stacked in huge mounds in fields, but farmers eventually began baling hay so that it could be conveniently stored in barns out of the weather. In this early version of hay baling, the hay was baled by a stationary steam-powered machine. Horses and wagons were probably used to transport both the loose hay and the bales. This image was taken by Bridgewater photographer J.M. Hill. (Courtesy ACHS.)

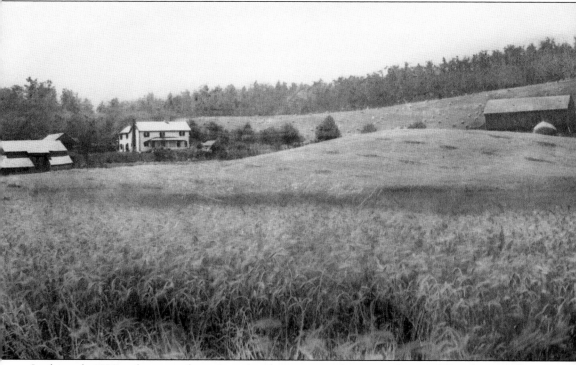

In the early 1920s, wheat was the universal cash crop grown by county farmers. This photograph clearly illustrates the succession of crops on a typical farm, as the farmer would grow corn in the summer that was then cut and gathered in circular shocks in the fall. The winter wheat was then planted in the fall around the shocks of corn. Throughout the winter, the farmer came out to the field to shuck the corn and haul off the fodder, a process that eventually left bare circles of earth throughout the wheat field. The wheat grew all spring and was harvested in the summer. In this photograph, taken just before the wheat harvest, the circles of bare earth can clearly be seen on the hill. (Courtesy Finley Lotts.)

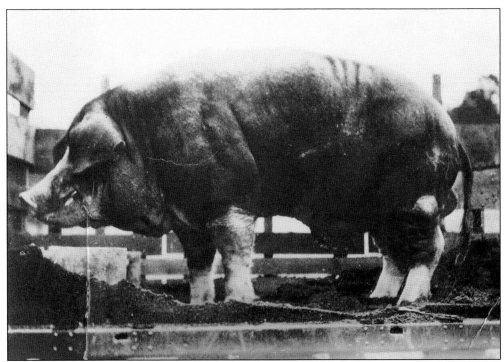

Spotswood Lad, a Poland China hog owned by Len McCray of Walkers Creek, began life as a scrawny runt in the late 1920s, but eventually became the world's largest pig, according to *Ripley's Believe It or Not!* He weighed 1,495 pounds, stood four feet, two inches tall, and was nine feet, eight inches long. Fairgoers paid 10¢ to view the prodigious hog standing behind a canvas sheet in the bed of a Ford Model A pickup truck. (Courtesy L.B. McCray.)

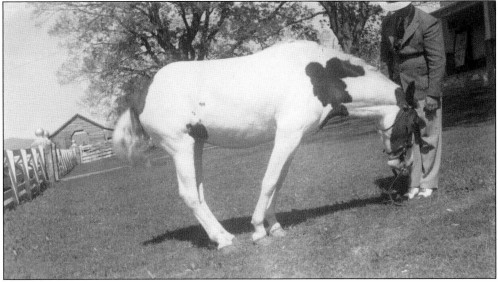

Pocahontas, an Appaloosa trick horse that lived at Rancho Rio in Craigsville, became nationally famous for a copper-colored mark on her neck that resembled an Indian head, complete with a single feather. Farmer Bob Anderson trained and showed the horse, who was born in 1935 and was also featured in *Ripley's Believe it or Not!* (Courtesy Virginia Davis.)

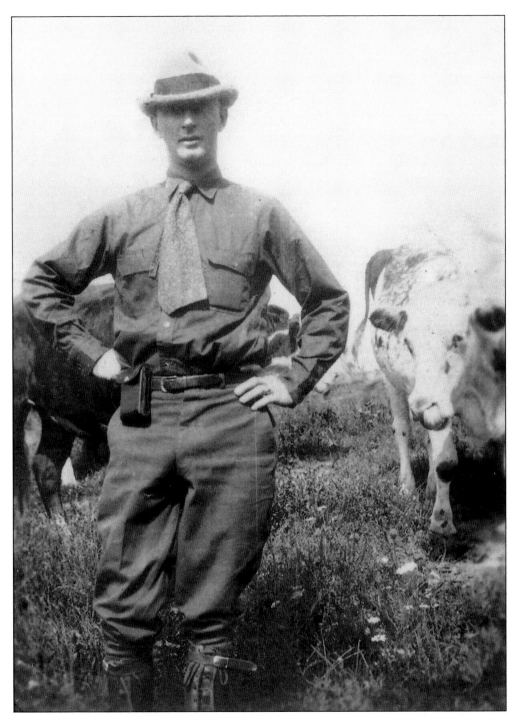

Bob Anderson of Craigsville stands in the field with his cows in the 1930s. The cattle appear to be shorthorn, the first breed of cattle introduced to the area and the most popular until the mid-1900s, when the red, white, and roan multipurpose cattle gave way to animals bred specifically for beef or dairy purposes. (Courtesy Virginia Davis.)

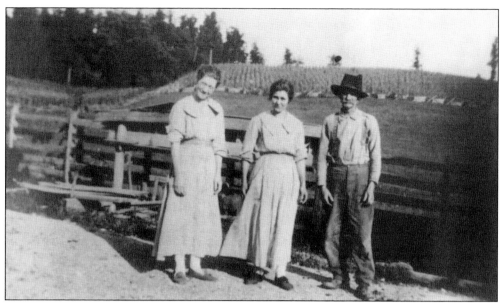

Lizzie Reardon, Emma Bartley, and Preston Arehart stand in front of the fields on the Arehart farm, near McKinley. Note the extensive cornfield behind them. Corn was perhaps the most important crop because it fed man and beast alike. As can be seen here, crop fields were enclosed temporarily with zigzag split rail fencing, while board fences were used for the more permanent barnyards. (Courtesy ACHS, AC Collection.)

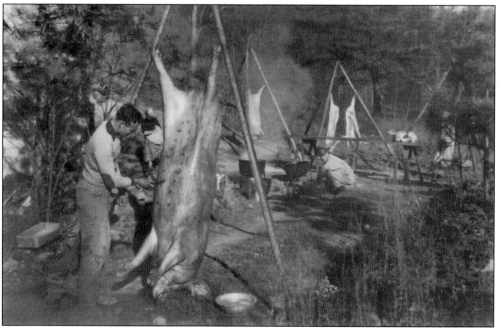

The most important animal on the farm was probably the hog, because it reproduced rapidly and fattened quickly on the chestnuts and acorns of the mountains. Farm families used "everything but the squeal" from a butchered animal, making sausage, lard, pan haus, and scrapple to eat and brushes and daubing from the animals' hair. Hog butchering took place in the fall after the weather had turned cool. (Courtesy JMUDSA, Geier Collection.)

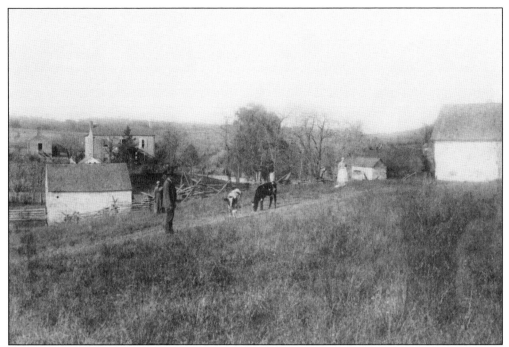

Long Glade Farm, located in northwestern Augusta County between Moscow and Spring Hill, has a history nearly as old as the county itself. Settled first by Thomas Waddell in the 1760s, it was sold to William and Sally Jones Howell in 1840, who lived and farmed there and are buried in the family cemetery. Their daughter Lucinda and her husband, Col. Samuel East, also lived there. Their son William Howell East served as a Virginia state senator. (Courtesy Janet Lembke.)

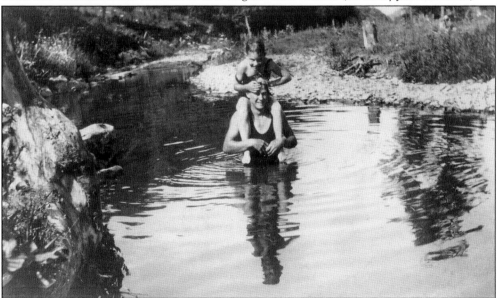

It gets hot in the summertime on the farm. And while wealthy folks might head toward one of the many resort springs for relaxing, socializing, and bathing, nothing beats simply taking a dip in a cool mountain stream in the hot summer, as demonstrated by this man and his son, wearing the latest in men's swimwear in the 1930s. (Courtesy Virginia Davis.)

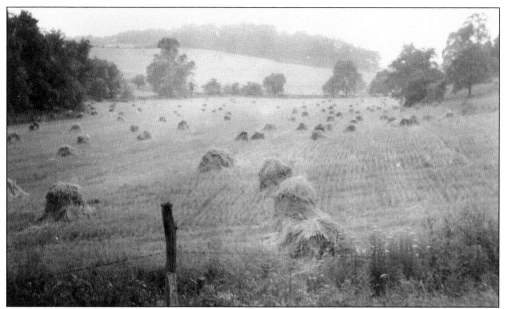

Sheaves of wheat are clumped in shocks in a western Augusta County field in the 1930s. From around the time of the American Revolution until World War II, wheat was the number-one cash crop in the county, meaning milling and distilling were the top industries. Augusta County flour went all over the world, including to the California gold camps. During the Civil War, this area was known as the Breadbasket of the Confederacy. (Courtesy Virginia Davis.)

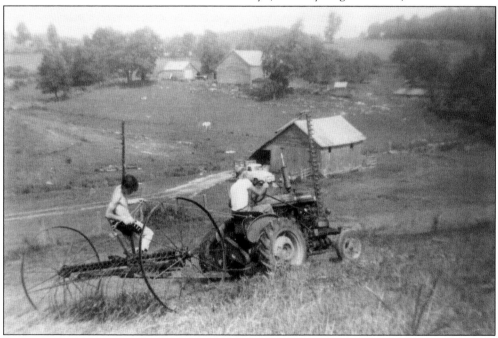

Between World War I and World War II, hay production for livestock became important to agriculture in Augusta County. Today, the county leads the state in hay production. In this photograph, Marvin Lee Collins and Clarence Reed rake hay in southern Augusta County on the Runkle farm. (Courtesy ACHS, AC Collection.)

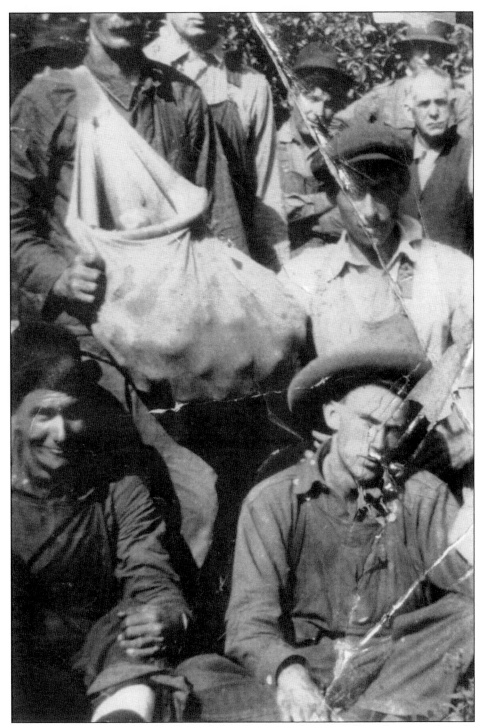

A group of workers from Churchville, including Jim Peters (bottom left), gathers to pick apples at the Crawford orchard, near Buffalo Gap. The orchard's owner is on the right near the top with a tie. The Crawford Manor subdivision was later built on the site of the orchard. At one time, Augusta County led the state in apple production. (Courtesy Mary Altizer.)

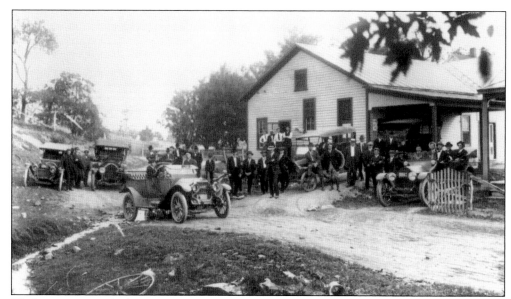

Workers pose outside the Augusta County Creamery, near Waynesboro, in 1915. Establishments like this mainly produced milk and butter, although they also rendered heavy cream and buttermilk in smaller quantities. Dairy farming became increasingly important in Augusta in the 1900s, as refrigeration allowed products to be shipped longer distances. By 1930, Augusta ranked first in the state in dairy cattle and produced 4.4 million gallons of milk. (Courtesy Lot's Wife Publishing.)

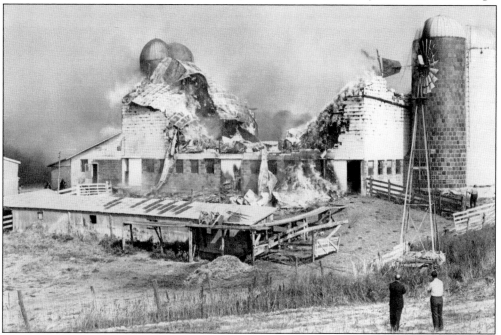

The Maple Lawn dairy fire occurred near Fishersville in 1965 and was fought by Augusta County Fire Department Company 10. The Augusta County Fire Department, established in 1941 in Staunton, was the first combination career-volunteer station in Augusta County. The fire department's station was originally located in an old school bus garage on Richmond Road, and the current station was built in 1971. (Courtesy ACHS.)

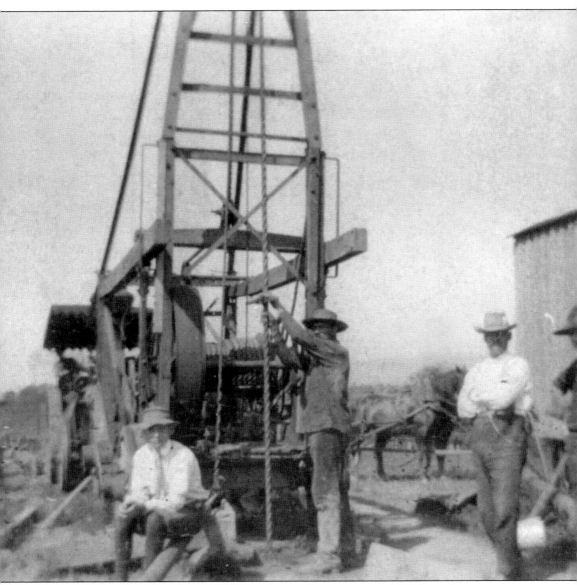

This well-drilling operation near Middlebrook, seen here are around 1900, used steam power, not diesel. If a farm did not have a good spring, digging a well was the next best option to have a reliable water source. (Courtesy ACHS, AC Collection.)

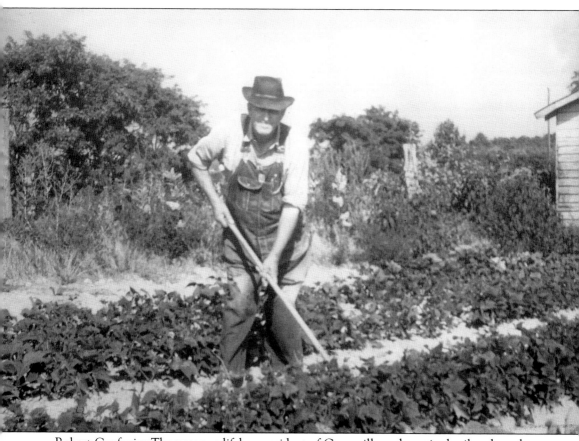

Robert Confucius Thompson, a lifelong resident of Greenville and a retired railroad employee, tends the extensive garden at his home place, a mile east of the village. This photograph was taken in the late 1950s or early 1960s. (Courtesy Sorrells family.)

Three

FACES AND FAMILIES

Settlement of the southern Shenandoah Valley began in earnest in the early 1700s, bringing new cultural groups to Virginia. Starting in Jamestown in 1607, the settlement of Virginia was a steady westward movement of English. By 1700, this English plantation system had progressed to the eastern foothills of the Blue Ridge. Crossing over the mountains and into the valley, however, presented many uncertainties, even beyond the arduous trek. Potential settlers from the east were reluctant to be cut off from transportation and supply routes in eastern Virginia and to be exposed to raids from the French and the Native Americans.

The solution came from southeastern Pennsylvania, where Presbyterians from the north of Ireland and German-speaking settlers from Europe had settled. As Pennsylvania land became more heavily settled, land prices rose, and settlers cast their eyes southwestward along the Great Wagon Road. Geographically, access was relatively easy—no mountains ranges were crossed, and the route followed the north-flowing Shenandoah River on a gentle uphill trek. The potential obstacle was that, unlike in Pennsylvania, where freedom of religion was practiced, Virginia had an established church with no separation of church and state. However, Virginia was so desirous of establishing a buffer between peaceful eastern settlements and the restless French and Indians to the west that religious toleration was expanded and land was offered at low prices. In the end, cheap land and the ability to practice their own religion won the day.

The 18th-century makeup of Augusta County was predominantly Scotch-Irish, with a strong component of German-speaking settlers. The English from eastern Virginia were a distant third. A fourth cultural group soon made its presence known in the valley: African Americans. Although most African Americans in Augusta were slaves, there was always a small free black population. By the eve of the Civil War, 20 percent of the county's population was African American.

Other ethnic groups began making their presence known in the 1800s, the largest being the Irish Catholics, many of whom arrived in the area after working on the railroad that ran from Richmond to Staunton and beyond.

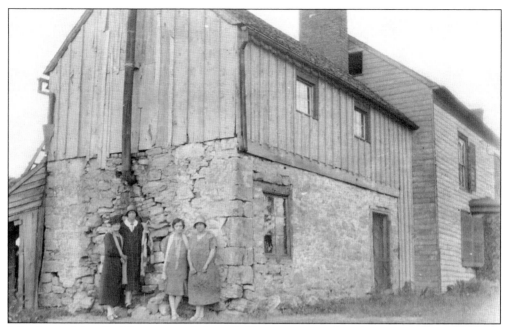

John Lewis, his wife, Margaret, and their children immigrated to America in the 1720s from County Donegal, Ireland, where Lewis had killed his landlord after an altercation that left Lewis's wife wounded and his brother dead. The Lewis family became leading citizens of this area, and John was often erroneously credited as being the first settler. Nonetheless, the Lewises did help settle the land, survey the wilderness, and open up Virginia's backcountry. Lewis's stone house, built in the 18th century, became a local landmark by the 20th century, as is seen here being visited by a group of unknown women. Although the 19th century log addition, right, survives, the stone portion is gone. When he died in 1762, John Lewis's grave contained a limestone slab that was replaced in the 1850s by the more elaborate tomb seen below, as well as a new inscription elevating Lewis to legendary status. More recently, the tomb was replaced again, but the inscription was kept. The entire gravesite, which probably contains the remains of Margaret and their son Samuel as well, is now enclosed with wrought-iron fencing. (Above, courtesy ACHS; below, courtesy Janet Lembke.)

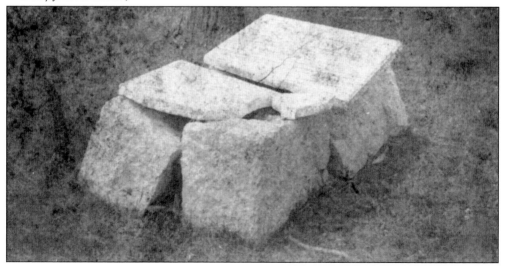

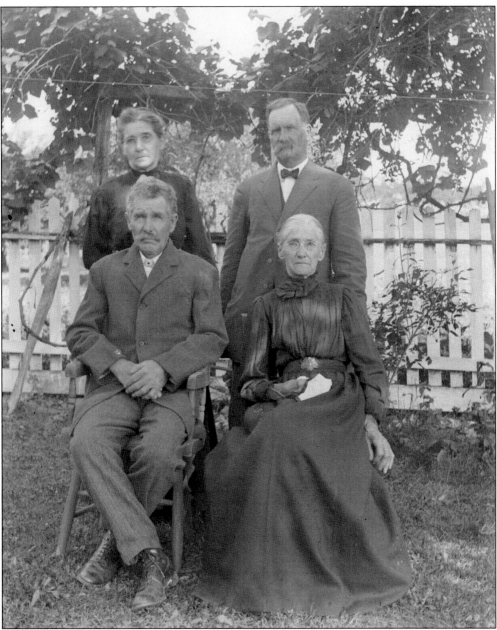

When the Coffman family of Mount Sidney gathered for a reunion of living siblings sometime before 1910, it was an opportunity for teacher and amateur photographer Henry Clay Coffman to photograph his family. He took this image of his father, Alexander Stuart Coffman (seated, left), a Civil War veteran and cabinetmaker, as well as his uncle and two aunts. Seated next to Alexander Stuart Coffman is his sister Elizabeth Coffman Aldhizer. Standing behind them are Nancy "Nanny" Mildred Coffman, who never married, and Enoch Thomas Coffman, who was visiting from Iowa. Today, the collection of glass negatives and photographs taken by Henry Clay Coffman is a unique and valuable part of the Augusta County Historical Society's archives. Many of his photographs provide the only record of rural Augusta County life a century ago, and a number are included in this book. (Courtesy ACHS, Coffman Collection.)

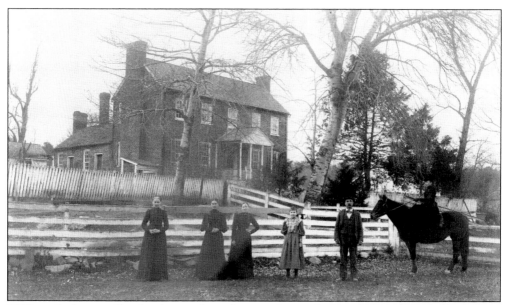

William Gayhart and his family pose for a photograph outside their fine, early-1800s brick home in Augusta County. (Courtesy ACHS.)

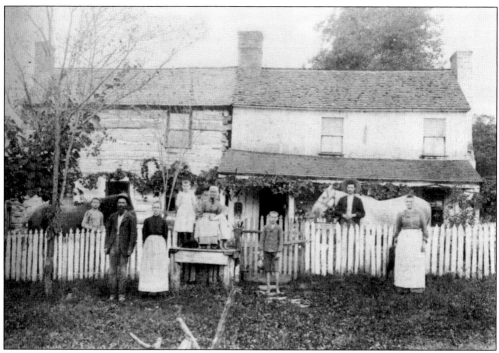

John and Mary Acord Spitler and their family stand in front of their home place in Haytie, west of Middlebrook, in the 1890s. Their postal address was Middle River. John and Mary are buried in the Mount Tabor Lutheran Church cemetery. (Courtesy John Brake.)

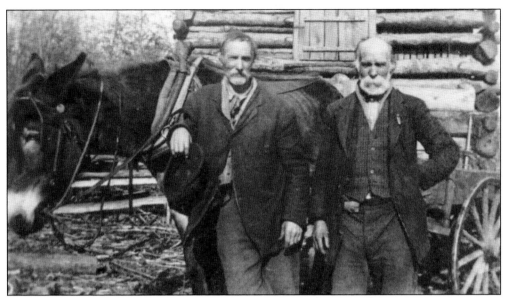

Andy "Old Mule" Cullen and John "Old Seatland" Cullen pose beside their mule and wagon in Greenville. (Courtesy John Brake.)

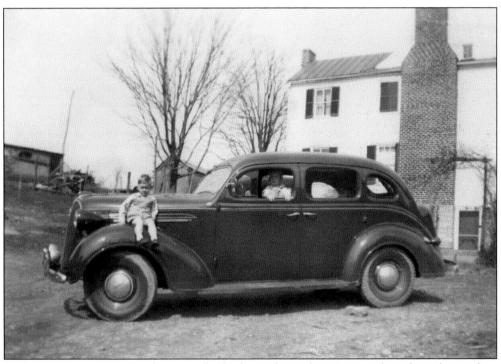

Family members Galen Hutchens, on the fender, and David McCray, peeking from the window, check out the first car ever owned by their relative Harry R. McCray, who bought this used 1937 Plymouth after returning home from World War II. This photograph was taken on the McCray farm, in southern Augusta County. (Courtesy Harry R. McCray.)

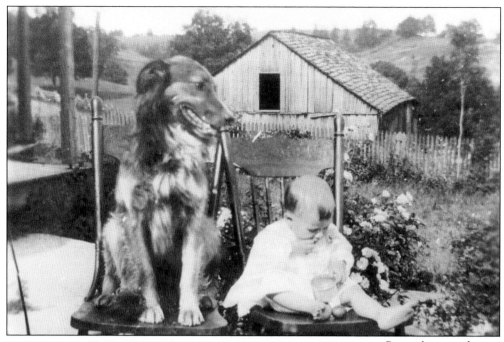

Puppy love on the farm comes through loud and clear in the photograph above. This collie mix farm dog shows great self-control as he looks adoringly at his young charge. Or is he eyeing the food that the baby is eating? (Courtesy Virginia Davis.)

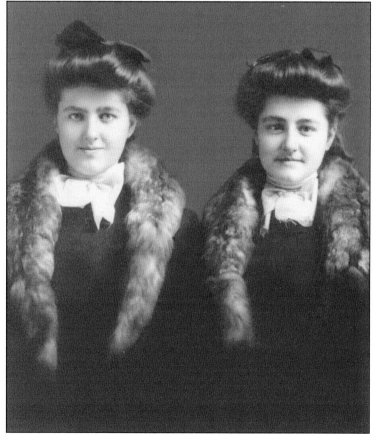

Here, Emma and Effie Fauver dressed in their best clothes, including matching fur stoles, for a trip into Staunton to be photographed. (Courtesy ACHS.)

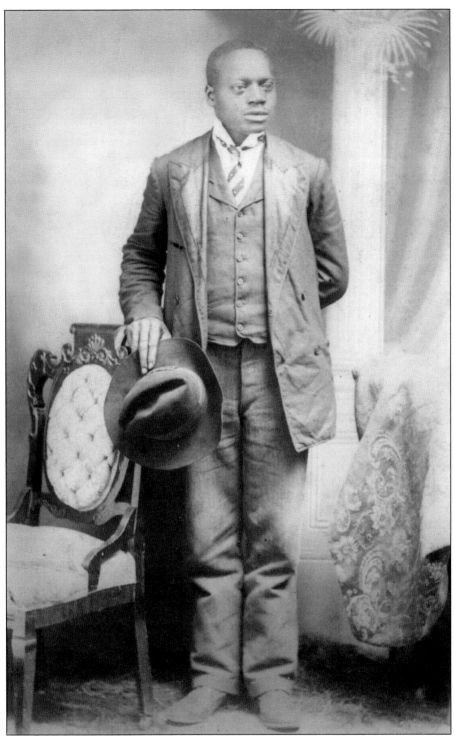

Farmer and businessman Noah Brown, who lived just south of Staunton on the Middlebrook road, was born in 1876 and died in 1952. The Brown family owned and worked a 100-acre farm at Arbor Hill. (Courtesy Walter Brown.)

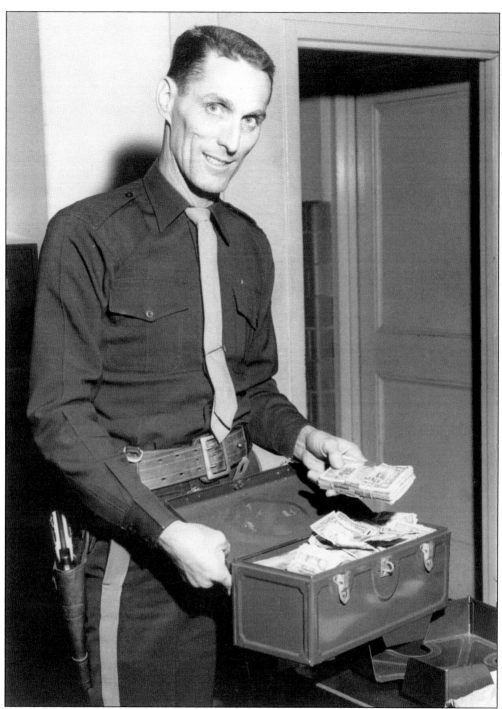

Augusta County sheriff John E. Kent displays the money recovered from a New Hope bank robbery that occurred on a March afternoon in 1961. Masked gunmen Erskine Glenwood Painter and Robert B. Lawson escaped with $18,500, but they revealed where they had hidden the money after they were arrested later that night. Police also recovered the guns the men had dumped in Lewis Creek. (Courtesy Augusta County Sheriff's Office.)

As the elected sheriff of Augusta County, John E. Kent was the face of security and confidence to area citizens for 27 years, from 1957 to 1984. Augusta County has elected a sheriff since 1745, but no man has served longer than Kent. In this photograph, Kent rides on a wagon leading a Weyers Cave parade as the parade marshal. (Courtesy Augusta County Sheriff's Office.)

An unidentified child plays on a homemade wagon near Craigsville, proving that fun does not have to be store bought. (Courtesy Virginia Davis.)

When newlyweds Anna Mary Robertson and Thomas Moses stepped off the train in Staunton for a weekend rest in 1887, they did not realize they would stay for 18 years. The couple was traveling from New York to North Carolina to work on a farm, but they were convinced instead to stay in Augusta and farm. Until family obligations called them back to New York, they farmed, ran a dairy, and gained a reputation for producing fine butter. Years later, the widowed Anna Mary "Grandma" Moses picked up a paint brush and, without any formal training, began painting the rural scenes she remembered from New York and Virginia. Several dozen of her paintings depicted scenes from Staunton and Augusta County, and she maintained a lively correspondence with the friends she had made in the Shenandoah Valley. All 10 of the Moses children were born in Augusta and five are buried here. This photograph, taken in 1950 when she was 89, was mailed to a friend in Augusta County. When she died in 1961 at the age of 101, Grandma Moses was one of the most popular folk artists in the country. (Courtesy ACHS.)

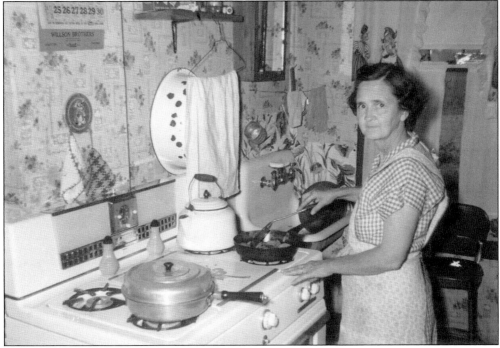

Be it ever so humble, there is no place like home—or the warmth of a farm kitchen. Farmwife Virginia A. Downs prepares a meal in the country kitchen of her home on Buttermilk Springs Road, just outside of Staunton. (Courtesy Janet and Earl Downs.)

The Beam family sits on the porch steps at their place in Swoope, where they owned several acres, raised chickens, grew a large garden, and butchered hogs. Identified in this photograph from around 1919 are Emma Sidney (Thomas) Beam (first row, right), Hubert Kemper Beam (second row, in hat), and, next to him, his daughter Virginia. Hubert Beam, a cooper by trade, worked for the Young Barrel Company in Staunton. (Courtesy Janet and Earl Downs.)

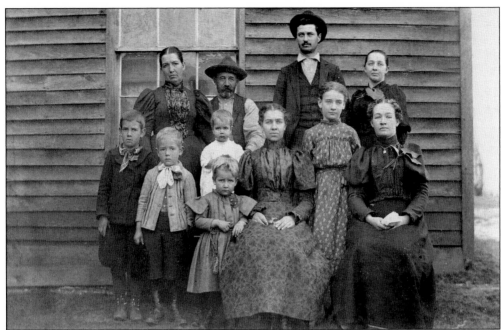

The William C. and Frances Bowman Bosserman family members are seen here around 1898 at their Mount Tabor farm, located between Staunton and Middlebrook. They are, from left to right, (first row) Raymond W. Bosserman, Ira Zirkle Bosserman, Glenna J. Bosserman, Sidney Bosserman (behind Glenna), Olive Pearl Bosserman, Lucy Bosserman, and Zola Aria Bosserman; (second row) Frances Bosserman, William Bosserman, Junius Edwin Spitler, and Gladys Bosserman Spitler. (Courtesy John Brake.)

This unidentified baby was photographed while sitting in a suitcase in Craigsville, in the western part of the county. After apparently being thrown out with the bathwater, he is packed and ready to get out of town. (Courtesy Virginia Davis.)

Two unidentified children sit for a photograph taken by local amateur photographer Henry Clay Coffman on a farm near Mount Sidney. (Courtesy ACHS, Coffman Collection.)

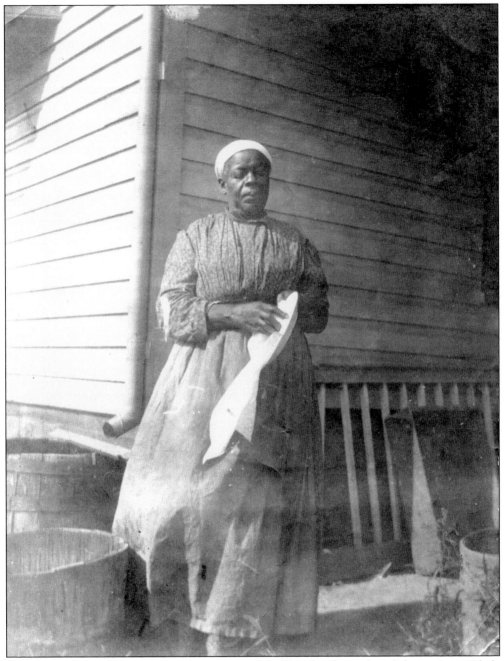

"Miss Aggie," the African American servant of the East family, washes dishes at Long Glade Farm, near Moscow. (Courtesy Janet Lembke.)

Lucy Virginia Howell East sits by the fire in her old age. She grew up on Long Glade Farm and married Col. Samuel Anderson East, who grew up nearby on Short Glade Farm. (Courtesy Janet Lembke.)

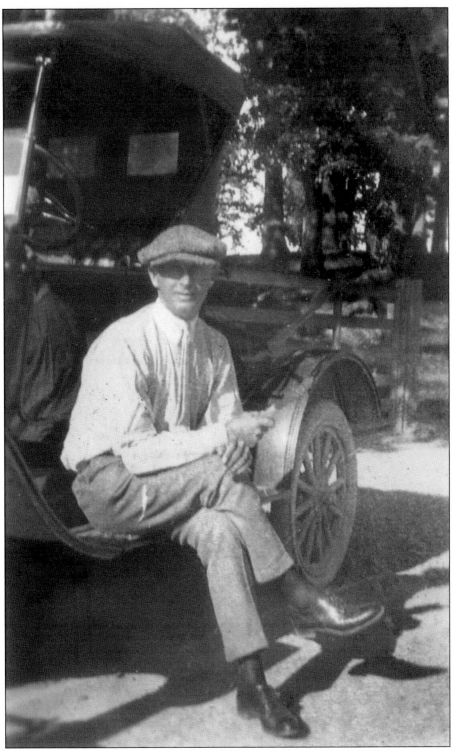

Bob Anderson strikes a relaxed pose on his wedding day on August 29, 1923, before marrying his wife, Lucy, at Hebron Presbyterian Church. (Courtesy Virginia Davis.)

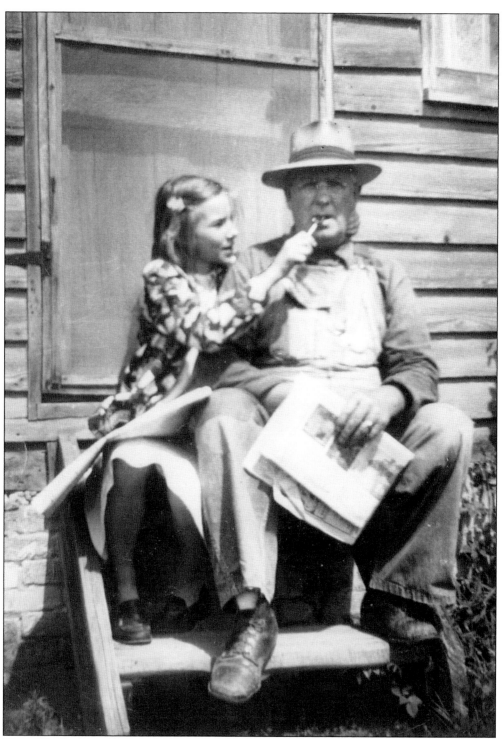

Elaine (Bradley) Moran feeds her grandfather Wilford C. Bradley a Popsicle while they sit together on his front porch near the Cold Springs railroad crossing, just east of Greenville along the Norfolk & Western line. (Courtesy Elaine Moran.)

Four

SCHOOLS AND CHURCHES

Churches and schools created a sense of permanence and security in backwoods Augusta County. The county government organized around the Anglican Church, Virginia's established church, while Scotch-Irish settlers also firmly planted Presbyterian congregations. The wave of German immigration after the American Revolution brought other denominations into the county, including Lutheran, German Reformed, Mennonite, and German Baptist, or Dunkards/Dunkers (now Church of the Brethren). More evangelical Methodists and Baptists followed in the early 1800s. Union churches, meetinghouses shared by several denominations, and African Methodist Episcopal (AME) congregations after the Civil War demonstrate Augusta County's strong religious tolerance.

The county's children matriculated with tutors at home or in field schools organized by groups of families. A private education was available to the wealthy at a number of independent academies such as Mossy Creek Academy and Loch Willow School. Mandated by the Virginia Constitution in 1870, Augusta County established its public school system the following year, and 88 schools sprang up throughout the county. Initially segregated, the schools finally integrated in 1966. Over time, the schools consolidated, grew, and changed to serve the growing population and reflect the educational reforms of the day. Schools today include a vocational-technical school, a Governor's School for technology and the humanities, and a community college.

Churches and school buildings dotted the hamlets, villages, and towns of Augusta County's changing landscape. Log meetinghouses at Tinkling Spring, Mossy Creek, and in other congregations gave way to stylish brick churches less than a century later. Also replaced were the small log, brick, and frame field schools, such as the Glebe School, which were replaced by larger, consolidated frame and brick elementary and high schools. The 1900s and early 2000s brought additions to old buildings as well as new construction to accommodate new and changing requirements.

Although early log and frame structures are rare, it is not difficult to find the modern manifestations of the churches and schools that lent permanence to and continue to serve the spiritual and educational needs of the citizens of Augusta County.

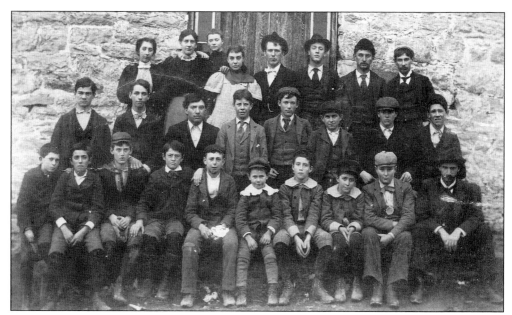

Starting in August 1888, Old Providence Associate Reformed Presbyterian Church in Spottswood operated Valley High School in its old stone building. The college preparatory school was open to boys and girls who paid between $30 and $45 per year depending on their classes. Out-of-town students boarded with area families. By 1921, the school had moved from the stone building seen in this late-1800s photograph. Eventually, the school was absorbed into the public school system. (Courtesy Old Providence ARP Church.)

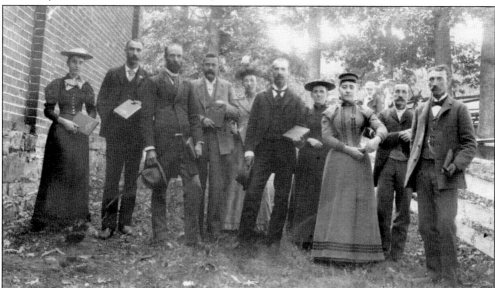

St. John's Reformed United Church of Christ is one of the oldest German congregations in Augusta County. The church, near Arbor Hill and Middlebrook, began as a union church with the German-speaking Lutherans who eventually formed their own church, known as Mount Tabor, in the 1830s. This photograph of the church choir was taken on October 6, 1894. From left to right are Box Hemp, Will Carrier, Fleto Fauver, Viola Rosen, Charley Kelly, Link Hemp, Frank Rosen, professor Price Howard Ellinger, and Bertie Ellinger. (Courtesy ACHS.)

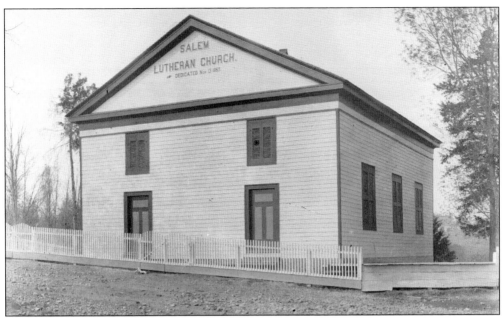

Salem Lutheran Church, located west of Mount Sidney, started as a union congregation of Lutheran and German Reformed denominations in 1805. The Lutherans exclusively owned the property by 1859, when the white frame church above, the second of three churches to occupy the property, replaced the original log structure. Itinerant artist Greenbury Jones painted its decorative interior (below). Jones specialized in marbleizing and wood graining; he used shadows to give a three-dimensional look to architectural features. The shadowed lettering seen below was one of his trademarks. Salem was the church of Ida Elizabeth Stover Eisenhower, the mother of Dwight David Eisenhower, the commander of the Allied invasion of Europe on D-Day in 1944 and the 34th president of the United States. (Both courtesy ACHS, Coffman Collection.)

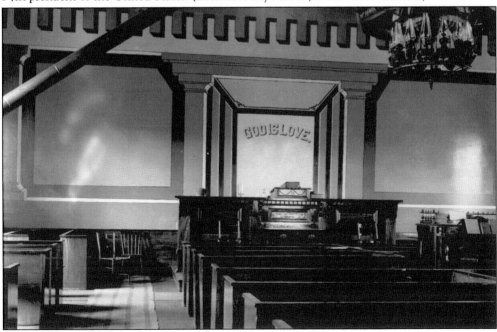

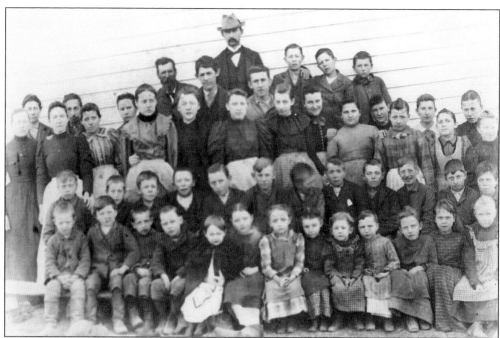

Students at the Summit School—including children from the Shull, Obaugh, Sheets, Craun, Showalter, Landes, Cline, Bell, Wise, Simmons, Huffer, Weaver, Sandy, Allen, Young, Varner, Mitts, Knicely, Moyers, and Croushorn families—pose for a school picture in 1895. Summit is located in northwestern Augusta County, between Route 11 and Route 42 near Centerville. Principal William Neff is in the fifth row, and teacher Ollie Cupp Moore is in the third row. (Courtesy ACHS, Coffman Collection.)

The Middlebrook School complex, built in 1910, exemplified the consolidated schools movement of the early 1900s. One- and two-room schools were closed and students were brought together in larger, architecturally stylish buildings with specialized spaces. These two schools in Middlebrook were erected in 1916 and 1923 as a high school and a grade school. Further consolidation led to their replacement by Riverheads High School in 1962 and Riverheads Elementary School in 1970. (Courtesy Harry R. McCray.)

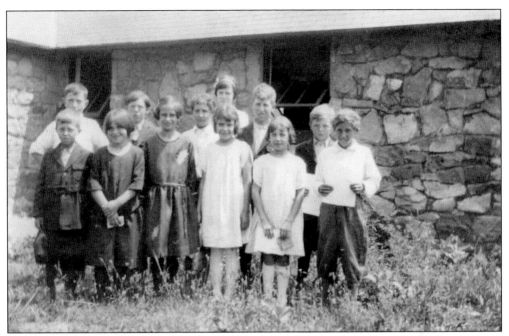

Members of the Good Shepherd Sunday school primary class stand outside of the newly completed church in 1925. Mildred Cochran, the founder of the church, was the class teacher. (Courtesy Good Shepherd Episcopal Church.)

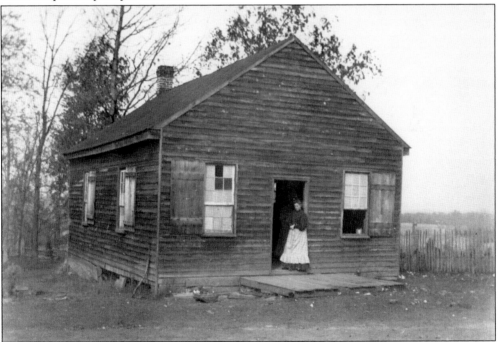

Limestone School, located near Mount Pisgah Church, was the school where Ida Stover Eisenhower, the mother of Pres. Dwight Eisenhower, went to school. She grew up in the area before moving to Kansas. The woman standing in the doorway is Lena Stover, a relative of hers. (Courtesy ACHS, Coffman Collection.)

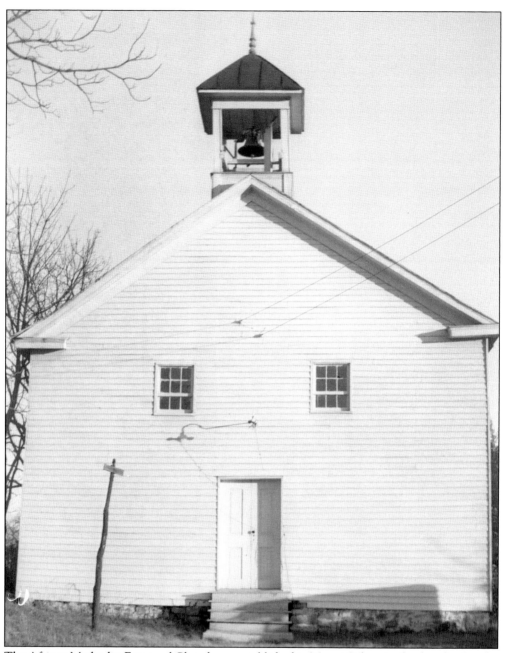

The African Methodist Episcopal Church was established in Mount Sidney in the decade after the Civil War. The property was purchased in 1864 and the congregation relocated and reconstructed the log building used by Salem Lutheran Church for its meetinghouse, where it met until the 1960s. (Courtesy ACHS, Coffman Collection.)

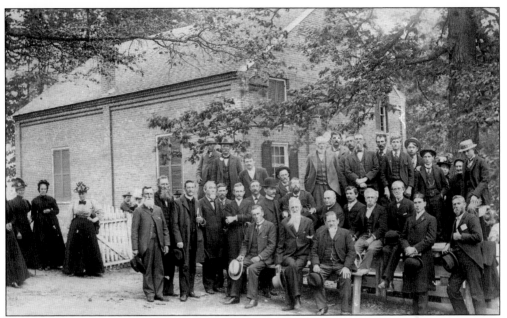

A group of German Reformed ministers, called a classis, gathers at St. John's Reformed United Church of Christ, located near the Howardsville Turnpike in southern Augusta County. The church, originally a union church made up of German-speaking settlers who were German Reformed and Lutheran, was formed about 1780. The building behind the group is the congregation's second church, built in 1850. Two more structures have been built since. (Courtesy ACHS.)

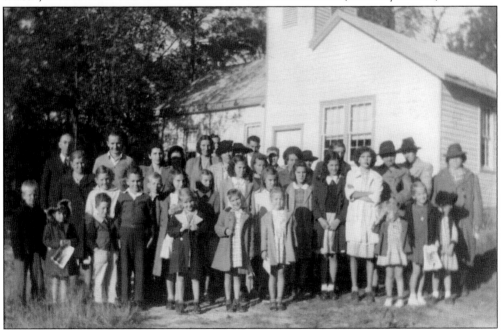

Rev. Herbert S. Turner, at left in the back row, stands outside of Pines Chapel with members of his congregation around 1944. Pines began as an outpost of Bethel Presbyterian Church around 1900 and became an independent church in 1994. By 1954, this white frame building had been replaced with a brick structure. (Courtesy Elaine Moran.)

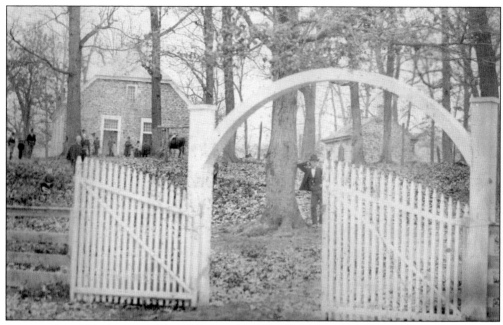

Augusta Stone Presbyterian Church, located in Fort Defiance, 11 miles north of Staunton on Route 11, is one of the oldest churches in Augusta County. Founded in 1738, it was organized as a united congregation with Tinkling Spring Presbyterian Church in 1740. Rev. John Craig served both congregations until their separation in 1764, when he stayed with Augusta Stone. A log structure east of the present site served as the meetinghouse until 1747, when the front of the building seen here was constructed. The church was enlarged in 1922 and again in 1956. This photograph was taken in the 1870s. (Courtesy ACHS.)

Together with Augusta Stone, Tinkling Spring Presbyterian Church, near Fishersville, lays claim to being the oldest church in Augusta County. The church, near a spring used by Native Americans as well as early Presbyterian settlers, was organized under John Craig in 1740, and a log structure was built around 1742. The structure seen here, the church's third, was dedicated in 1850. It is still used today, although significant modifications have been made over the last century and a half. (Courtesy Tinkling Spring Presbyterian Church.)

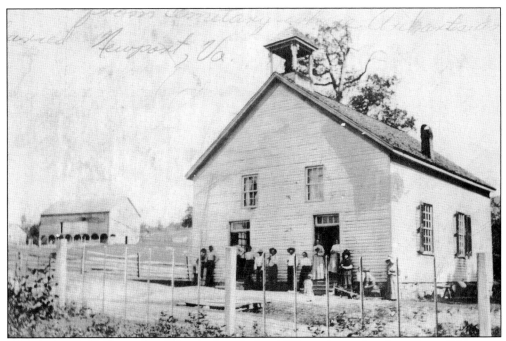

Mount Hermon Lutheran Church, seen here before 1918, was located in the village of Newport, south of Middlebrook. The church operated from 1852 until at least 1964 and eventually combined with two other local Lutheran churches to form Redeemer Lutheran in nearby McKinley. Another building replaced this one, erected about 1857, but there is no longer a building on the site, only a cemetery. (Courtesy William Arlen Hanger.)

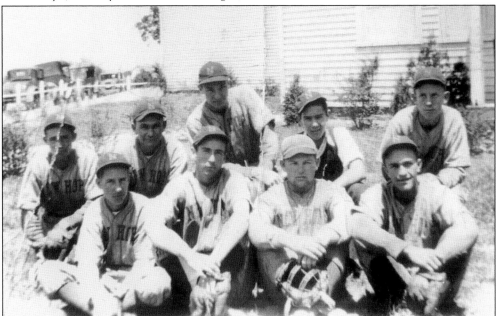

Who said school was all work and no play? In 1932, the New Hope High School baseball team won the county championship by beating Vesuvius 2-1 in 16 innings. Nelson Burkholder (first row, far right) pitched all 16 innings. (Courtesy Owen Harner.)

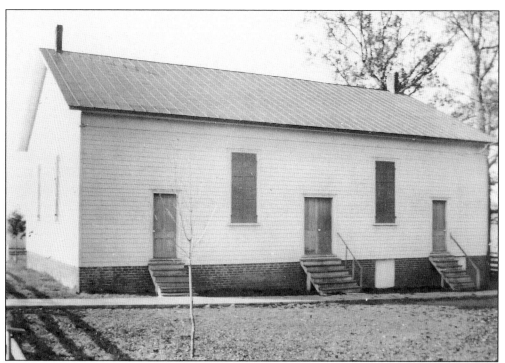

German Baptist Brethren, or Dunkers, as they were pejoratively called, arrived in the Shenandoah Valley in the 1750s. The first Dunker church in Augusta County, the Middle River Church, was constructed in 1824 under the leadership of Abraham Garber. This Anabaptist sect held fast to its pacifist teachings yet found itself witness to the 1864 Battle of Piedmont. The church served as a hospital after the battle. Known as Middle River Church of the Brethren today, it is located two miles northwest of the village of New Hope. (Courtesy ACHS, Coffman Collection.)

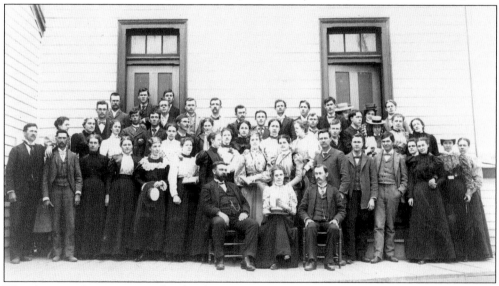

The Augusta County Normal School, in Mount Sidney, trained teachers for area schools. Identified in this photograph are, in no particular order, Henry and Rose Coffman, Elna Peters, Sam Huffman, and Homer Craun. (Courtesy ACHS, Coffman Collection.)

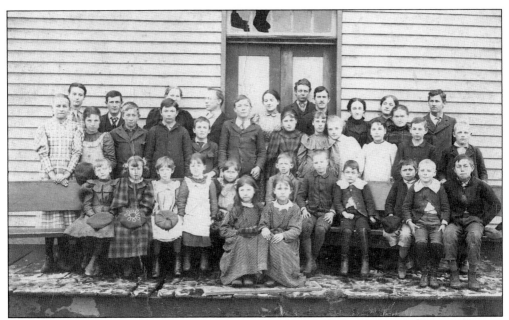

Students pose for a school photograph in front of an unidentified school in the Craigsville area. (Courtesy Virginia Davis.)

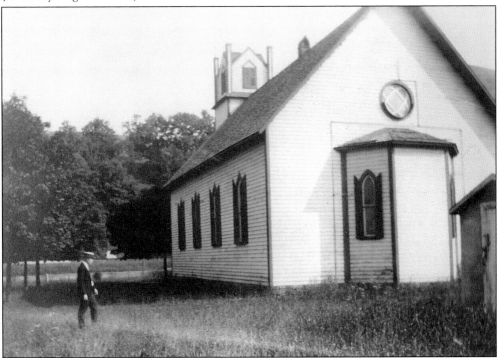

Craigsville Presbyterian Church began as a Sunday school in a local schoolhouse in 1868. The small congregation secured land and laid a cornerstone in 1895, but the Lexington Presbytery did not recognize the church until 1897. First called Bethany Presbyterian Church, the name was then changed to Craigsville Presbyterian. Additions and renovations were made to the building in the 1950s, the 1990s, and in 2009. (Courtesy Virginia Davis.)

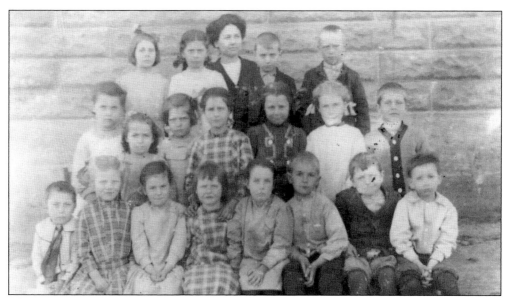

Above, Mount Pisgah School students pose for their class picture in 1912. Identified are, in no particular order, Richard Wine, Sadie and Virginia Sheets, Arthur Beery, Arlene Hudson, Viola Sheets, Thelma Hudson, John A. Coffman, and Crawford Sheets. Teacher Lillian Wine Cupp stands in the center of the third row. None of the students are identified in the undated Pisgah photograph below. The boy in the upper left corner shows off his baseball mitt. The community of Mount Pisgah is located west of Fort Defiance. (Both courtesy ACHS, Coffman Collection.)

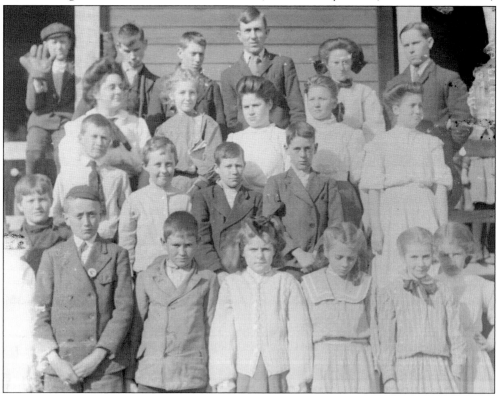

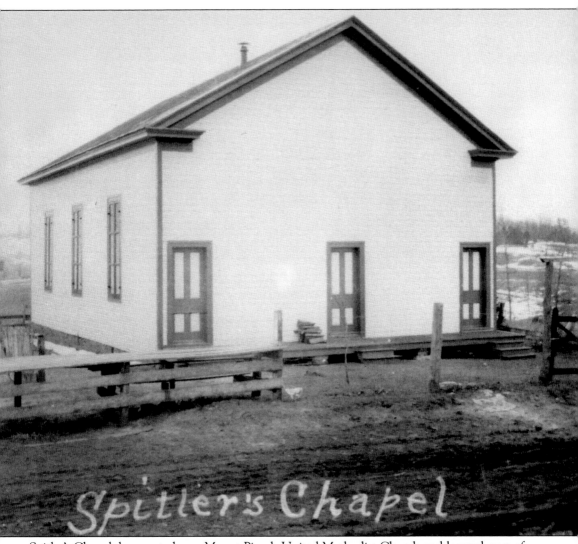

Spitler's Chapel, known today as Mount Pisgah United Methodist Church and located west of Fort Defiance, began as a United Brethren Church in the 1850s. The frame church seen here was built in 1884, replacing the original log structure. A newer building was constructed in 1951. The denomination became the Evangelical United Brethren in 1941 and later merged with the Methodists to form the United Methodist Church. (Courtesy ACHS, Coffman Collection.)

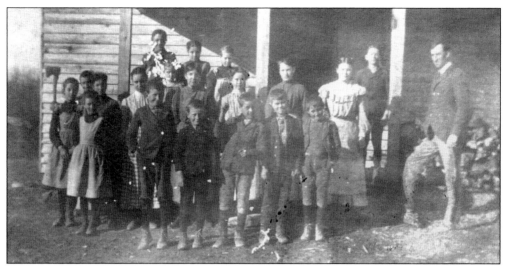

Pine Top Public School No. 18 was located on the north side of a large bend in the Middle River. This photograph shows William Newton Bailey (right), the acting teacher at Pine Top, and his students around 1900. The school, situated between Fort Defiance and Laurel Hill, was in existence since at least 1884, when it was found on the Jed Hotchkiss map of the Middle River Magisterial District. (Courtesy Dorothy Lee Rosen.)

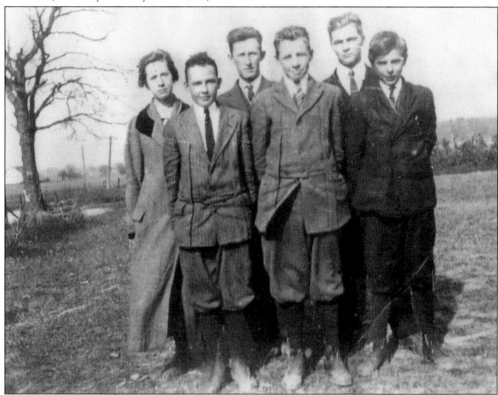

The New Hope High School class of 1918 is seen here posing for its graduation picture. The graduates were, from left to right, (first row) Harry Bauserman, Sautelle Ratchford, and Clyde Spitzer; (second row) Mary Rene Borden, Gib Carter, and Eldridge Aldheiser. (Courtesy Owen Harner.)

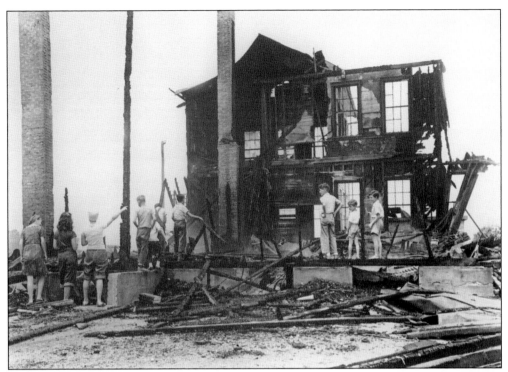

An early morning fire in June 1946 destroyed the frame grammar school in New Hope. Augusta County School superintendent A.C. Gilkeson estimated the damage to be between $12,000 and $15,000. (Courtesy Owen Harner.)

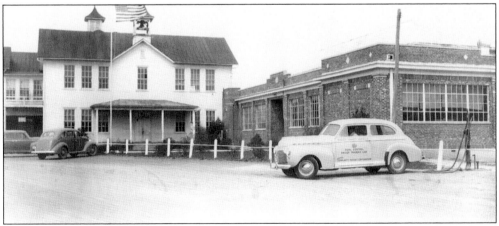

A drivers' education car is parked prominently in front of the second (built in 1905, left) and third (1924) New Hope schools. (Courtesy Owen Hanger.)

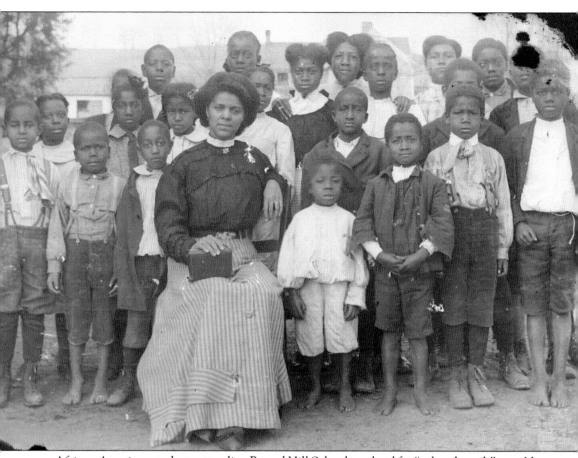

African American students attending Round Hill School, a school for "colored pupils" near New Hope, pose with their teacher. The school eventually consisted of two buildings, one built in 1881 and one built in 1924. Alverta Lewis may be the teacher seen here with roughly half of the students enrolled in the 1909–1910 school year. Each magisterial district had schools for African American students; the Middle River District, in which New Hope is located, topped the list with five. Augusta County schools desegregated in 1966. (Courtesy ACHS, Coffman Collection.)

Five

ROADS, RAILS, AND PLANES

Although Native Americans had lived in the valley for at least 10,000 years, Augusta County was uninhabited by indigenous peoples by 1700; however, the Warrior's Path remained a hunting and travel corridor used by Native Americans. This ancient pathway, which ran southwestward from eastern Pennsylvania, was quickly adopted as the main thoroughfare by settlers. The narrow, rutted path, initially suitable only for foot or horse traffic, was soon cleared and widened and became known as the Great Wagon Road.

By the early 1800s, some improved roads incorporated and charged tolls at tollhouses built at intervals along the road. A long wooden pole, called a pike, was stretched across the road to stop traffic. When the toll was paid to the gatekeeper, the pole was lifted or turned, thus giving rise to the name for such roads: turnpike. Different tolls were charged to travelers on foot and horseback, and for different vehicles such as carts, stagecoaches, buggies, and covered wagons. Drovers also paid per head of livestock.

By the early 1800s, the Great Wagon Road had been graded and macadamized with a smooth surface of packed stone. The improved road became the Valley Pike, and turnpike villages such as Mount Sidney, Greenville, and Steeles Tavern dotted Augusta County from north to south. In the early 1900s, tolls were discontinued and the Valley Pike evolved into Route 11. There were other turnpikes, including the Warm Springs Turnpike, the Parkersburg Turnpike, the Brownsburg Turnpike, and the Howardsville Turnpike, which ran east over the mountains to the James River and Kanawha Canal.

The iron horse was slow to arrive in the southern Shenandoah Valley. The Virginia Central Railroad chugged into Staunton from the east in the 1850s. After the Civil War, two north–south railroads, the Norfolk & Western and the Baltimore & Ohio, operated in Augusta, and the Chesapeake & Western came from eastern Rockingham County, connecting Augusta with the West Virginia coalfields.

Airborne vehicles became a common sight in the county shortly after the Wright Brothers. In 1923, the USS *Shenandoah*, a naval dirigible, flew over the area to the delight of residents. Perhaps the most important pilot to land a plane in Augusta was Charles Lindbergh.

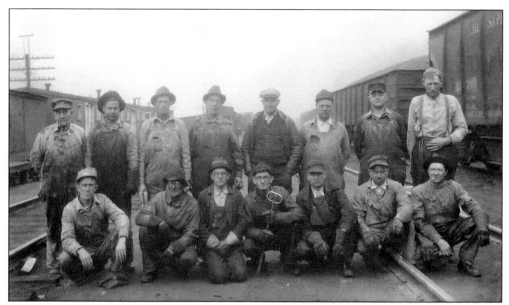

A Norfolk & Western railroad crew pauses from its work along the Augusta and Rockbridge County portion of the line. The Norfolk & Western ran north to south along the eastern portion of Augusta County. (Courtesy Elaine Moran.)

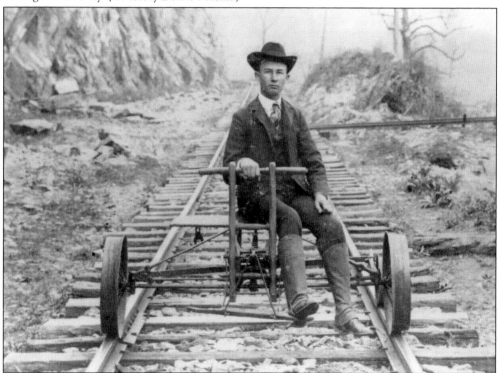

Railroad worker Claude Carver travels the tracks for maintenance work in this special contraption. Carver was working on the tracks in the North River area of northwestern Augusta County. This photograph was taken by Rockingham County photographer Homer F. Thomas. (Courtesy Dorothy Thomas.)

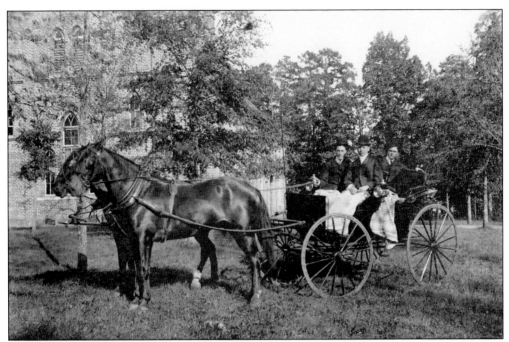

Sightseeing on country roads was as common in the days of horses and carriages as it is today with automobiles, as can be seen in this photograph of young men out for a ride. The day must have been a little brisk, because they all had blankets covering their legs. (Courtesy Chris Furr.)

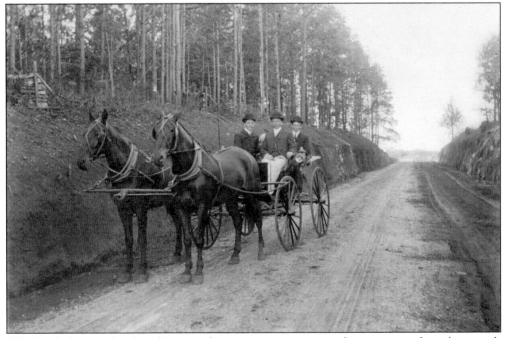

Whether before or after their first stop, the same young men paused again to pose for a photograph along what was certainly one of the nicest roads in the county. The road is wide and nicely graded, with a smooth surface. There is a good possibility that this is the Valley Pike. (Courtesy Chris Furr.)

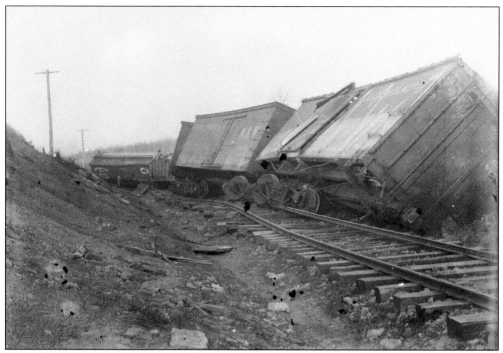

Derailed train cars lie jumbled along the Baltimore & Ohio line near Weyers Cave, in northern Augusta, around 1900. The three cars are from the Baltimore & Ohio, the Norfolk & Western, and the Chesapeake & Ohio, the three railroad lines that ran through the county. They probably ended up together because Staunton was a freight hub and cars were shifted between lines as needed to transport products. (Courtesy ACHS, Coffman Collection.)

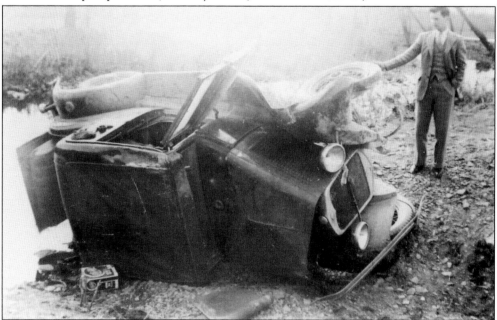

A young Bobby Lee Anderson looks over what is left of his automobile after he wrecked the vehicle near Craigsville about 1944. (Courtesy Virginia Davis.)

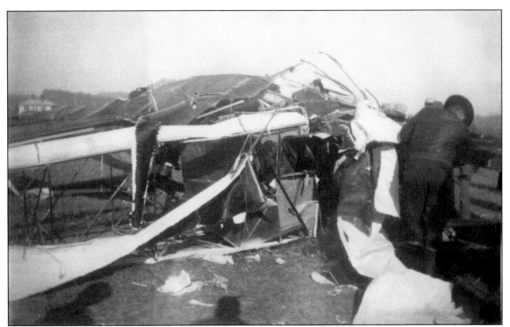

Augusta County's first air fatality occurred in Verona in November 1930. Hundreds of spectators came to Bowling Air Field, located south of the Route 11 and Route 608 intersection, where the Augusta County government center is now located, to watch and maybe ride in pilot Jarius Collins's Stinson Junior Detroiter cabin plane. Two Mount Sidney men, Samuel Driver and Greenlee Bosserman, and Roman resident Paul Rimel boarded the plane in the afternoon for a 10-minute flyover. The plane lost power a few minutes into the flight after a left bank maneuver and crashed into the ground. Collins, Driver, and Bosserman were killed, but Rimel survived with broken bones. (Above, courtesy ACHS; below, courtesy Joe Glovier.)

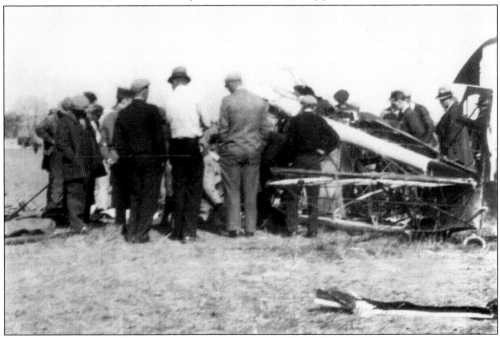

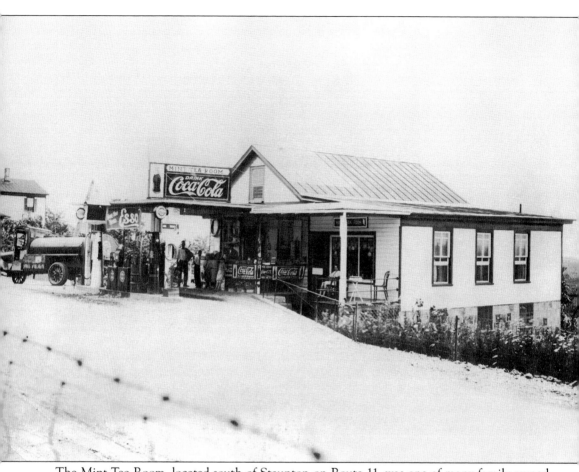

The Mint Tea Room, located south of Staunton on Route 11, was one of many family-owned establishments catering to local residents and travelers. Strategically located along both the main highway and the Baltimore & Ohio Railroad in the village of Mint Spring, the business was owned and operated by Edwin Luther Harris and his wife, Dora. Customers could purchase gasoline, produce, and home-cooked meals, pick up mail, and buy train tickets. Harris bought the business in 1917 and added the tea room in 1922. In the late 1920s, there was even a tent on the property that provided overnight lodging. Eventually, the interstate and chain gas station/convenience stores rendered such places irrelevant. (Courtesy William Arlen Hanger.)

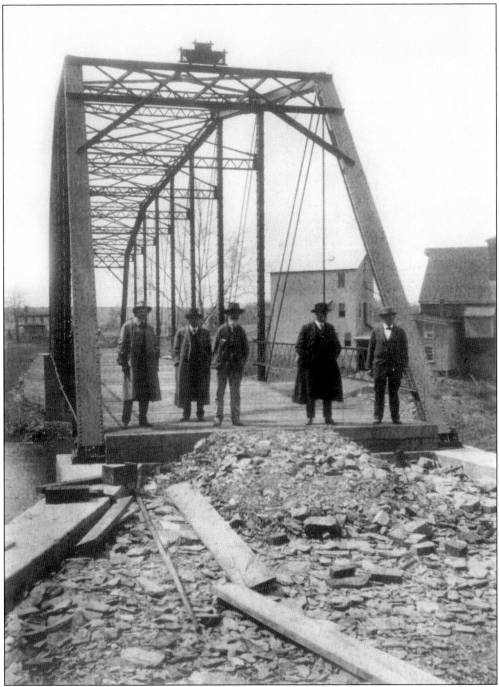

The Knightly Bridge, seen here under construction in 1915, carried Route 778 across the Middle River near New Hope, just south of Knightly. The 182-foot-long, single-span, pin-connected camelback truss bridge was one of five that crossed the Middle River. It was one of many steel truss bridges built in Augusta County in the early 1900s as part of the "Good Roads" movement. (Courtesy Owen Harner.)

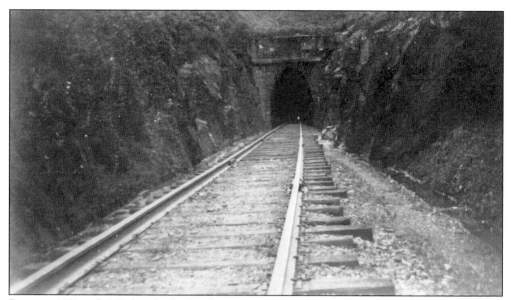

Between 1850 and 1858, hundreds of Irish immigrants and dozens of African American slaves used hand picks and blasting powder to dig a 4,264-foot tunnel 700 feet underneath the Blue Ridge Mountains, connecting Nelson and Augusta Counties by rail from eastern Virginia. The 1850s tunnel, abandoned by the Chesapeake & Ohio Railroad in 1944, is currently being restored as a greenway. The 1850s tunnel project, led by French-born engineer Claudius Crozet, is a National Historic Civil Engineering Landmark. (Courtesy ACHS.)

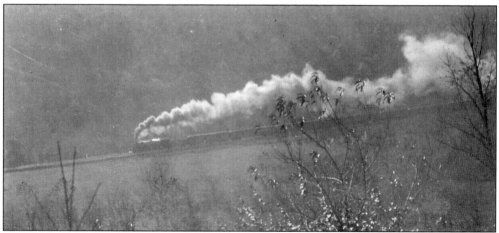

"There goes Old No. 4" is what Anderson family members used to holler when the Chesapeake & Ohio train came chugging past their Craigsville farm, Rancho Rio. (Courtesy Virginia Davis.)

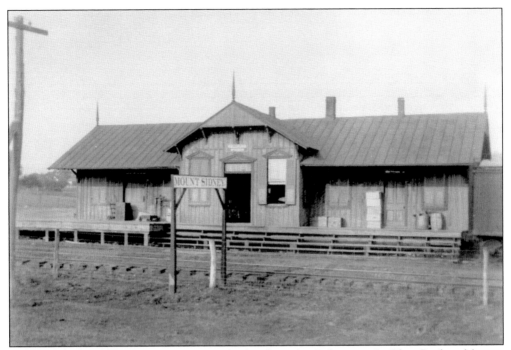

The Mount Sidney railway station was built when the Baltimore & Ohio Railroad began service between Baltimore and Staunton in 1874. The large building served as a passenger and freight station until it was torn down in the early 1940s during World War II. (Courtesy ACHS, Coffman Collection.)

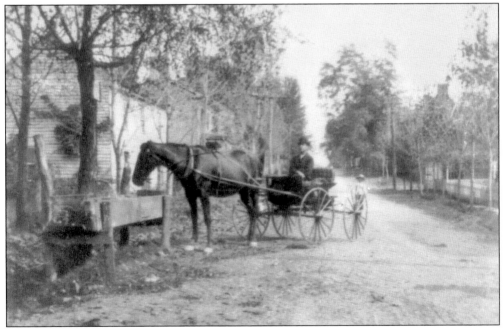

A horse stops to drink from the public water trough along the main street in Mount Sidney. People still generally referred to the thoroughfare as the old Wagon Road, but, in the village, it was called Washington Street. (Courtesy ACHS, Coffman Collection.)

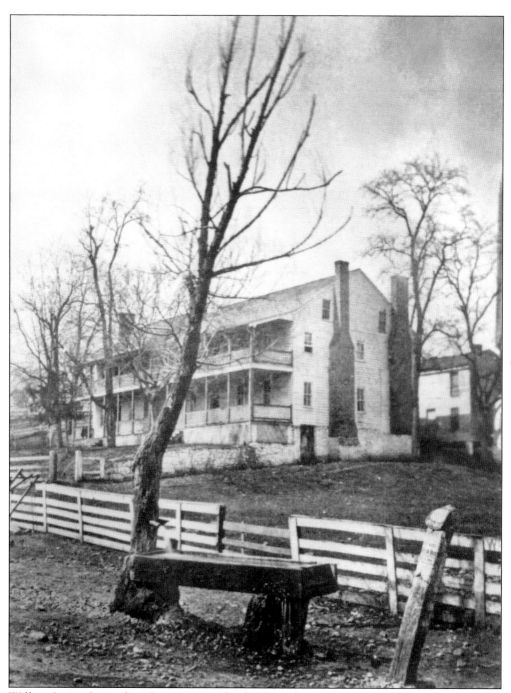

Willow Spout, located on Route 11 south of Fort Defiance, provided water to travelers and animals traversing the Great Wagon Road, one of the oldest roads in the Shenandoah Valley. Water flowed from a spring through a 15-inch-diameter willow log, which was later replaced by a pipe. The spout also provided water to the many distilleries in the area. The Hanger Tavern is seen in the background. (Courtesy John Wayland Collection.)

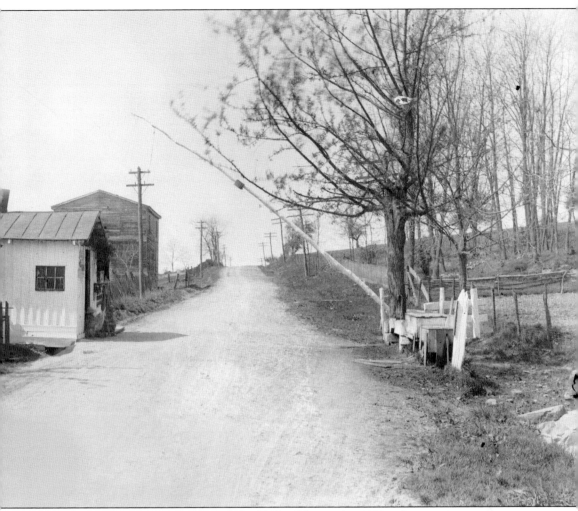

The Great Wagon Road was renamed the Valley Pike in the 1830s when a private company straightened and macadamized the road and began charging tolls. Tollbooths were erected approximately five miles apart. The pike, made from a long tree branch, was turned to allow traffic to pass when toll money was tendered. Thus, the word turnpike became synonymous with toll roads. (Courtesy ACHS, Coffman Collection.)

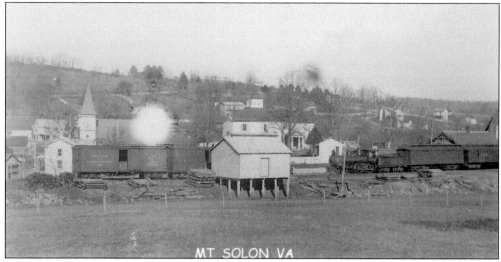

Mount Solon is a quiet rural community typical of those in northwestern Augusta County. It once boomed with businesses served by the Chesapeake & Western Railroad, seen here in the foreground. The C&W, as the line was called, was jokingly referred to as the "Crooked and Weedy" by the locals. During the town's halcyon days in the early 1900s, a local bank built a fine brick building replete with Greek columns. The building later served as the post office. (Courtesy Joe Glovier.)

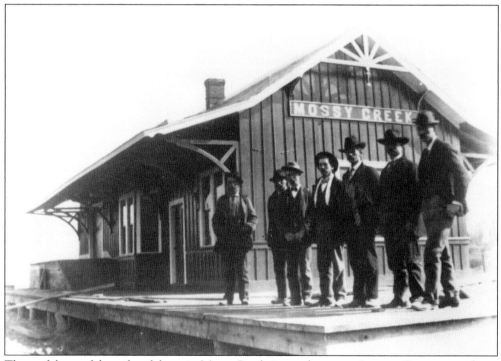

The usefulness of the railroad depot in Mossy Creek, in northwestern Augusta County, was short-lived, as the Chesapeake & Western first came through the area in order to connect with the West Virginia coalfields about 1900 but was discontinued and dismantled around 1930. (Courtesy ACHS, Coffman Collection.)

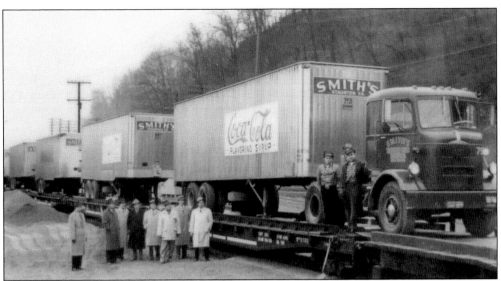

Roy Redman "Jake" Smith and his two brothers, Russell Bell and Raymond Neff Smith, founded Smith's Transfer Corporation north of Staunton in 1930. It eventually became one of the largest trucking companies in the United States, expanding through innovative business practices and the acquisition of other trucking companies. R.R. Smith, the company's president, championed the use of piggybacking trucks on the railroad, as seen above on the Chesapeake & Ohio line with officials from Smith's Transfer, the Coca-Cola bottling works, and the railroad. Smith enjoyed transportation of any sort and acquired a company airplane (below) for business trips and meetings. He piloted the aircraft himself starting in early 1940, although he later employed a company pilot to fly the plane. Always community minded, Smith chaired the Shenandoah Valley Airport Commission and supported local historic preservation projects. Smith's Transfer Corporation eventually became a subsidiary of Automatic Retailers of American, Inc. After a series of complicated mergers, buyouts, and bankruptcies, Smith's was absorbed by American Freight Ways of Topeka, Kansas, and the Verona portion of the business was closed. The trucking terminal in Verona was purchased by Augusta County and converted into the government center. (Both courtesy R.R. Smith Center for History and Art.)

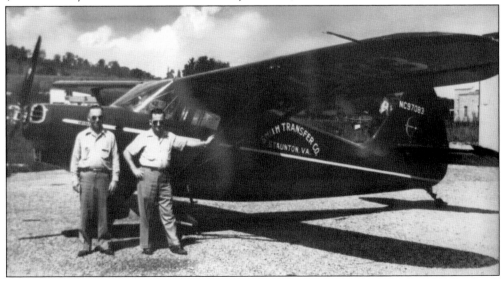

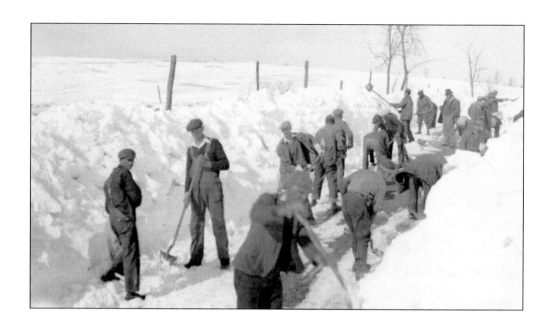

A significant snowstorm in the late 1920s or early 1930s closed Augusta County roads. A scarcity of snow removal equipment meant that old-fashioned manpower was required to clear the road just north of Staunton, near Verona. The photograph above was taken by Arthur Moore, who was born in 1891 and worked for the newly formed Virginia Department of Highways. (Both courtesy Joe Glovier.)

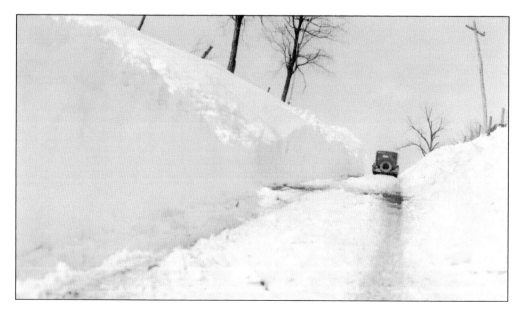

Six

MILLING AND DISTILLING

Augusta County settlers may have come into a wilderness, but they arrived with the purpose of tapping into eastern commercial markets and making money. Once land was cleared, the most important crops were grains—corn, wheat, rye, and oats—that fed man and beast. Very quickly, industries to turn grain into cash were built along fast-moving streams. Mills converted grain into meal and flour, while distilleries turned corn, rye, and wheat into liquid gold. Both flour and alcohol could be shipped to market for a profit, but whiskey provided a higher return per bushel of grain. The two industries vied to be the county's top industry.

Mills were so numerous that farmers never had to travel far to find an outlet for their crops. One historian estimated that Shenandoah Valley streams produced more mills than any other place on earth. Even before Augusta County established an operating government, in 1745, there were operating mills. Literally hundreds of mills have been documented, many of them changing names as owners and technologies changed. Smaller rural mills were usually toll mills, meaning that the miller kept a portion of the farmer's flour or meal as payment without cash changing hands. Larger mills operated on a cash basis and shipped flour to big cities. It is easy then to understand why Cyrus McCormick invented the grain reaper here—because he lived in the grain capital of the world. However, McCormick moved to Chicago because he recognized that the future of grain production was the Great Plains. By the 1950s, Augusta's mills had all but disappeared.

Distilling also experienced a rise and fall. Whiskey making was brought to the valley by the Scotch-Irish and, during the American Revolution, their skill pushed British-made rum out as America's drink of choice. By 1800, one quarter of Augusta's estates had stills, and larger commercial distilleries were springing up, coinciding with Americans' heaviest drinking period, of 7.1 gallons per capita. But even before Virginia established prohibition in 1916, the temperance movement had captured American hearts, and the very people who had embraced distilling turned their backs on the industry. By the mid-1900s, Augusta's grain was mostly corn, which was mostly used for animal feed.

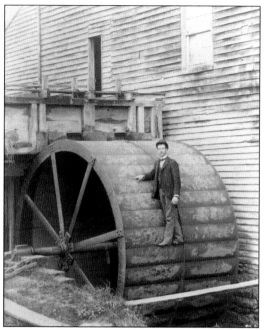

In 1906, photographer Homer Thomas perched on one of the slats of the Mossy Creek Mill waterwheel, just south of Bridgewater, and took this self-portrait. Thomas was a photographer in the Dayton-Bridgewater area in the early 1900s. Mossy Creek, in northwestern Augusta, has been the site of industrial activity, including iron making, papermaking, and milling, since the 1700s. (Courtesy Dorothy Thomas.)

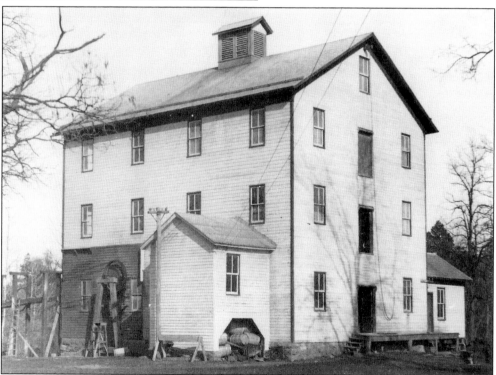

Located on North River near Weyers Cave, Rockland Mills has had a long history along this section of the river. Flour and grain were shipped north on the river by long, low gundalows to the Shenandoah River and then on to the Potomac, where they wound up in Alexandria and Washington, DC. By 1910, the mill was also producing electricity for the area. (Courtesy Janet and Earl Downs.)

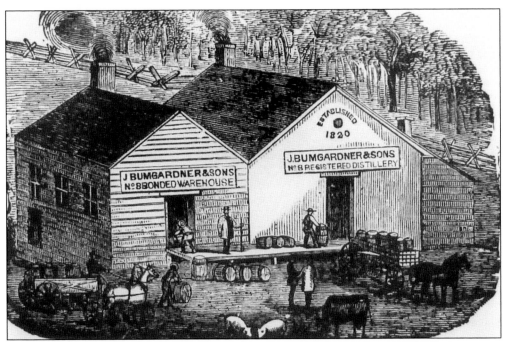

The Bumgardner Distillery, seen above in a drawing from an invoice, began in Page County when Christian Bumgardner and his son Jacob traveled to Boston semiannually before the American Revolution to sell their whiskey. Eventually, the family moved to Augusta, where they operated their distillery from 1820 until Virginia prohibition shut it down in 1916. From the beginning, the distillery, near Greenville, enjoyed a national reputation for its fine rye whiskey. For much of its existence, however, the temperance-minded Presbyterians at Bethel Church, seen at left in the photograph below, worried about the distillery. When the church was remodeled in 1921, it used the walnut lumber from the closed distillery for its doors, pulpit, and railings, thus finally bringing demon whiskey under church control. (Both courtesy Rudolph Bumgardner III.)

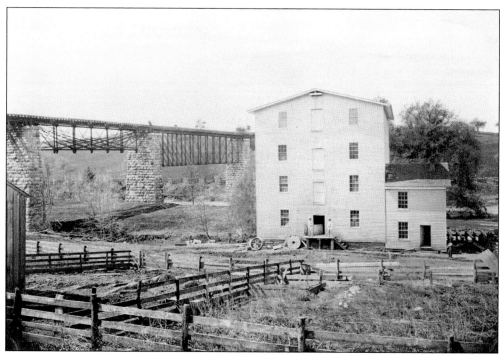

Bowlings Mill, in Verona, which was known as Clines Mill until the 1870s, stood on the north bank of the Middle River east of Route 11. These two photographs, taken by professional photographer George S. Aldhizer, offer a varied perspective of the typical mill scenes. (Both courtesy ACHS.)

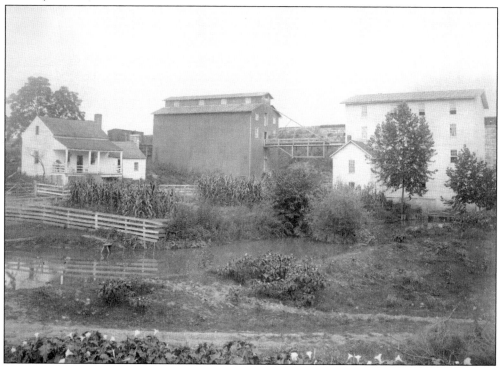

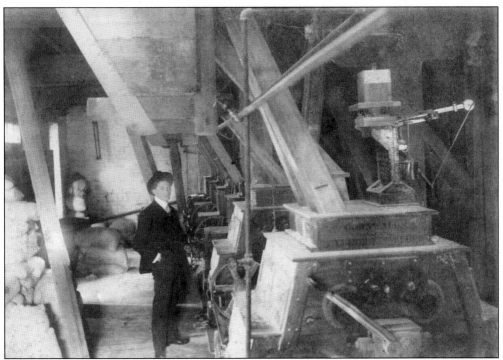

Floyd Furr is seen above inside the Greenville mill, on the South River, and below standing outside with his family (center) and two mill hands (far left and far right), covered in flour. Furr was the owner of the mill at the time. Local farmers would bring wheat, corn, and other grains to the mill for grinding into flour. The owners often kept a portion of the flour as payment, which they later sold for a profit. The mill changed hands in 1920 after a flood destroyed the dam twice, but it ran under new ownership until the late 1950s, when it finally went out of business. (Both courtesy Chris Furr.)

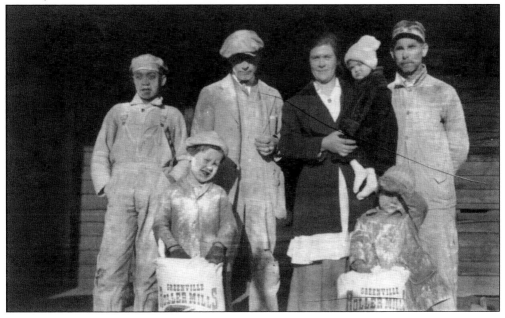

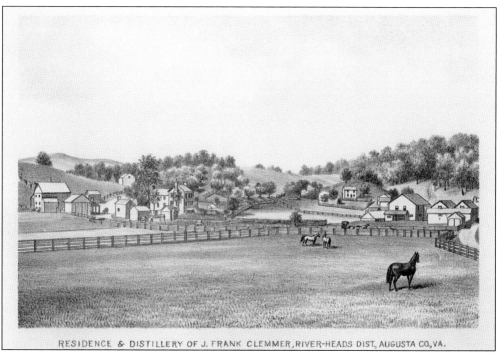

RESIDENCE & DISTILLERY OF J. FRANK CLEMMER, RIVER-HEADS DIST., AUGUSTA CO, VA.

The other nationally known Augusta County whiskey was the Clemmer brand. George D. Clemmer moved his family operation from Pennsylvania to Augusta County after the Whiskey Rebellion of the 1790s. The extensive distillery operation, seen in this 1884 drawing, operated on a farm south of Middlebrook. Family stories point to the fact that Clemmer whiskey was the top seller in the California gold camps. (Courtesy ACHS.)

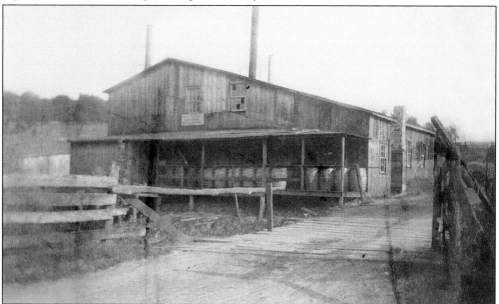

Little is known about this c. 1900 photograph of W.C. Fulcher's distillery on Middlebrook Road, just outside of Staunton. The 1884 Hotchkiss map shows a Myerly's distillery in the same location, which is now Middlebrook Avenue and is within the city of Staunton. (Courtesy ACHS.)

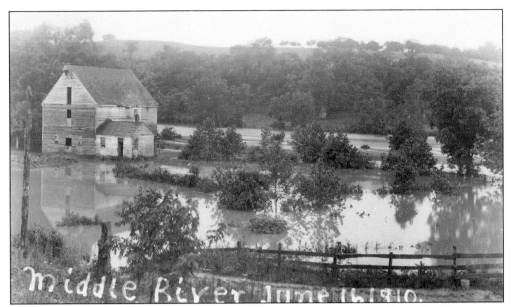

As long as mills used water to power the equipment, they were susceptible to flooding, as can be seen in this photograph of the June 16, 1910, flood of the Middle River. (Courtesy ACHS, Coffman Collection.)

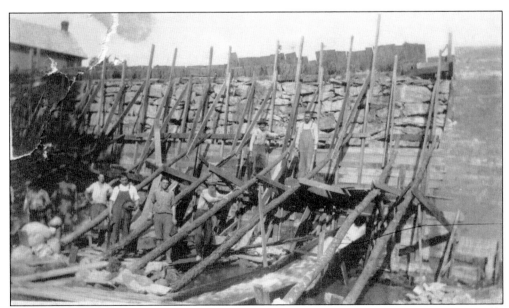

On July 28, 1920, Dow Photography Studios in Staunton captured this image of the Greenville mill dam being repaired for the second time that summer. Floyd Furr, who owned the mill, had just finished repairing the dam when floodwaters destroyed it again. (Courtesy Chris Furr.)

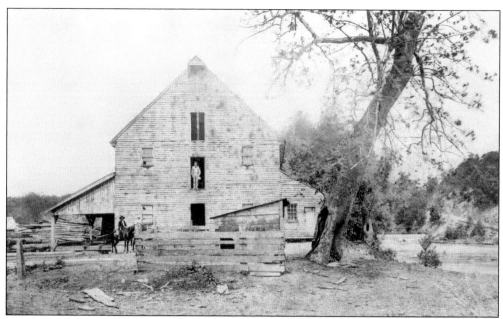

Knightly Mill, located on the Middle River near New Hope, dates back to the 1830s and has gone by a variety of names. The photograph above is the oldest known photograph of the mill, and the 1927 photograph below shows the mill undergoing a conversion into a hydroelectric plant to supply electricity to the neighborhood. The new power lines can be seen in the foreground. Rather than grind grain, the Knightly Light & Power Company sold electricity. It was eventually purchased by Virginia Electric Power, which is known as Dominion today. (Both courtesy ACHS, Coffman Collection.)

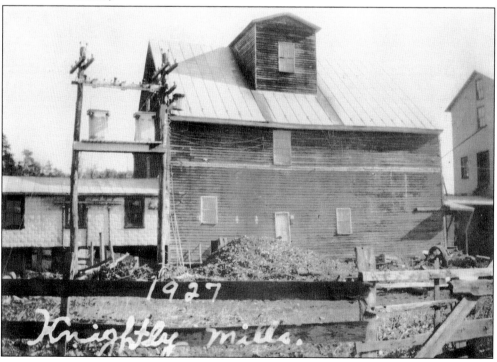

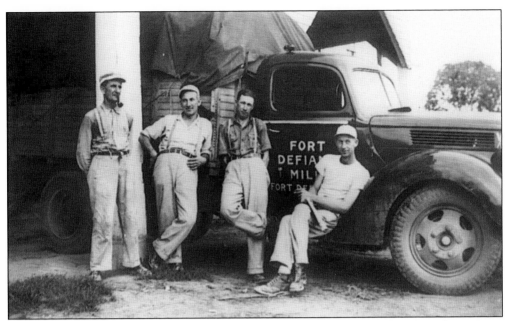

From left to right, miller Rob Mowry, miller John Garber, truck driver Hugh Hall, and Fritz Stout take a break while leaning against the Fort Defiance Mill truck in 1935. The mill, on the Middle River, was destroyed by a fire in 1960. (Courtesy Owen Harner.)

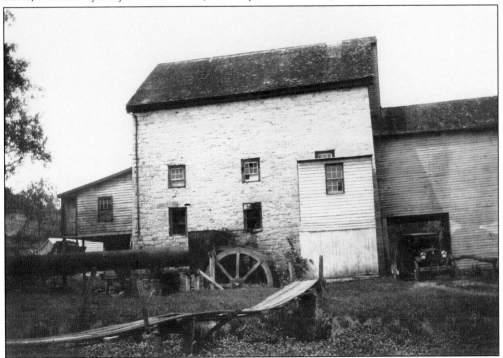

The Drumheller Mill, formerly known as Garber Mill and Sites Mill, included a sawmill and a cider press. After operating for 160 years, the mill was disassembled and moved to Michie Tavern in Charlottesville, where it is part of a tourist attraction known as Meadow Run Mill, named after the stream that powered it in Augusta County. (Courtesy Janet and Earl Downs.)

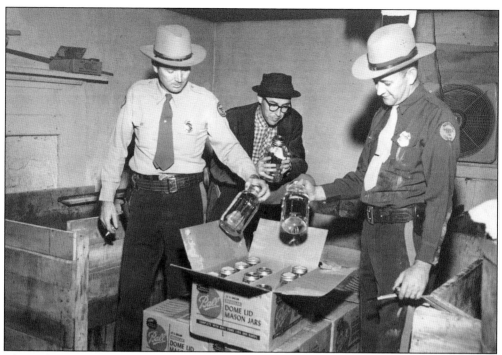

These photographs show sheriff's office officials examining the barrels and jars of moonshine confiscated during a 1957 raid on an illegal whiskey still in a tenant house near Mint Spring, just east of Route 11. The still was one of the largest ever found in western Virginia and was capable of producing 200 to 300 gallons of liquor per day. Nearly 4,000 gallons of fermenting mash were stored in 19 wooden barrels and vats, and over three tons of sugar was found in an upstairs room. Deputies poured out the mash and smashed the containers before apprehending three men, one of whom abandoned his truck and fled into the nearby woods before being caught. (Both courtesy Augusta County Sheriff's Office.)

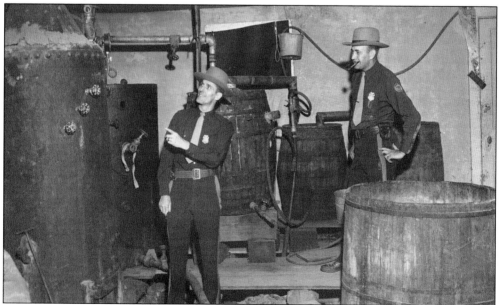

Seven

MINING AND MANUFACTURING

In Augusta, farming complemented the related industries of milling and distilling, but several mineral extraction industries also thrived in the mountainous foothills on the eastern and western edges of the county, where the geology differed radically from the valley's karst topography. The dominant mining-related industry was probably iron making, and an ironworks flourished in Mossy Creek in the 1700s, producing firebacks, kettles, and other iron implements. Near Sherando, the remains of the Mount Torry ironworks can still be seen. That furnace operated from 1804 until 1854 and reopened in 1861 to supply pig iron to the war effort. Union troops destroyed it in 1864, but the furnace reopened for a couple of decades after the war before closing permanently before 1900.

After iron, the next most important mineral to be mined was manganese, which was found in large seams in the Blue Ridge Mountains of eastern Augusta. Today, deep gashes in the earth remain from extensive surface mines in Crimora, an operation that once led the world in manganese production. In southeastern Augusta, a series of manganese mines operated, from Cold Springs and Lofton down to Vesuvius. All had shut down by the 1950s.

Kaolin, referred to locally as chalk, was mined from at least two sites in the Lyndhurst and Cold Springs area. The Lyndhurst product was used to make porcelain, while the Cold Springs material was sent by cable cars down the mountainside to the railroad, where it was pulverized and baked before being sent off to be used mostly as paper filler by the *Washington Post*.

Anthracite coal was the draw in the North River Gap, and the Dora Coal Mine shafts were opened and tested sporadically between the 1880s and the 1940s, with very little success. In the Craigsville area, limestone was mined for Portland cement and marble was quarried nearby. Of course, on the valley floor, limestone quarries for rock and lime kilns for making lime were commonplace. A small bauxite mine operated for a while in the southern part of the county, and there were at least three silver mines in the county.

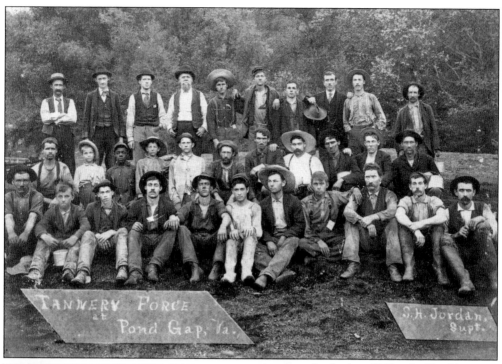

In the late 1800s, the Kunkle tannery (above), at Pond Gap, was among the largest employers in the Augusta Springs community, along Route 42 west of Staunton. Pond Gap is the old name for Augusta Springs. (Courtesy Fridley family.)

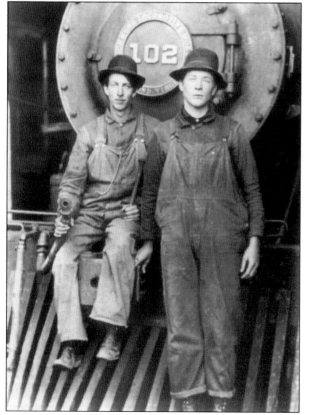

The heart of the Stokesville community was the Chesapeake & Western Railroad, which terminated in Stokesville with a railhead. Here, two railroad workers sit on an engine at the engine house. (Courtesy JMUDSA, Geier Collection.)

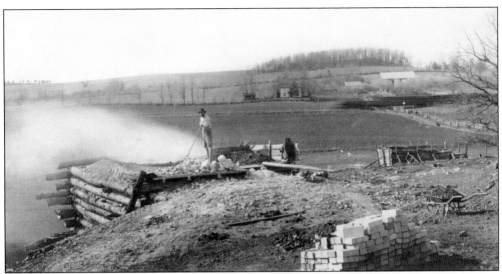

Ira Driver tends a lime kiln on his farm near Mount Sidney. Such small industrial complexes were common in places where limestone was the dominant rock. To make lime, crushed limestone was turned into a fine powder by heating. The resulting product was spread on fields to reduce soil acidity, mixed with water to form paint called whitewash, or used to make plaster for finishing walls. (Courtesy David McCaskey.)

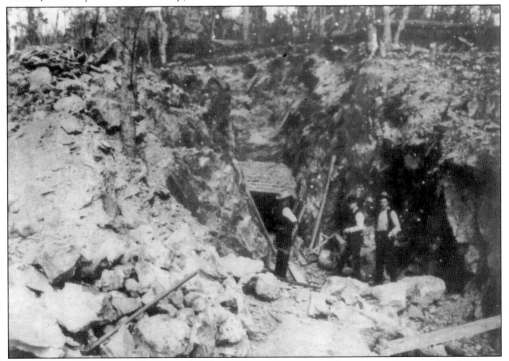

Pockets of anthracite coal exist in the North River Gap area of Augusta and were mined since at least the 1880s. The lure of potential profit from coal mining helped fuel the industrial boom of Stokesville. The Dora Coal Mine appears on maps as early as 1884 and was still being explored in the 1940s. This photograph is the only known image of the Dora Coal Mine shaft. (Courtesy JMUDSA, Riddleberger Collection.)

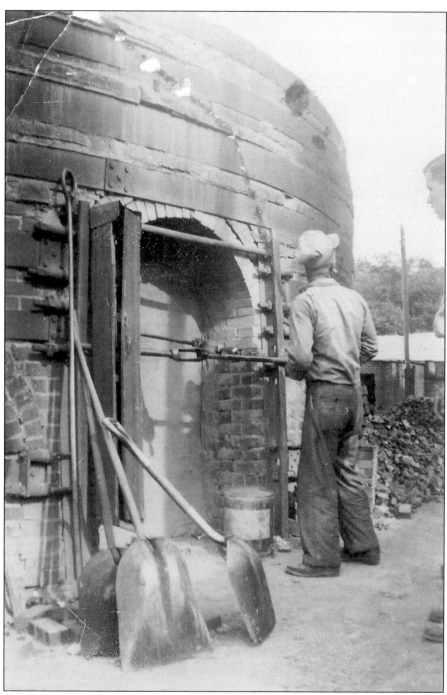

The North Mountain Brick Company, located 14 miles west of Staunton near Buffalo Gap, manufactured bricks until the 1960s. Clay was coarsely crushed, mixed with water, and packed into brick molds. Molded bricks were then passed by hand to the kiln for firing. John Ailer is seen here monitoring the kiln's temperature. When the temperature reached 2,000 degrees Fahrenheit, the fire was put out. The bricks then stayed in the kiln until they were cool enough to be removed by hand. (Courtesy Mary Altizer.)

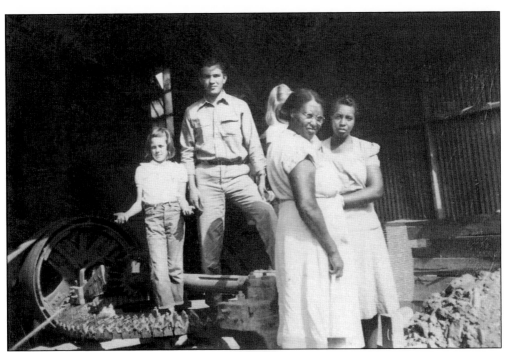

Above, from left to right, Betty Peters (Kennedy), John Altizer, Peggy Peters, and Ginny and Callie Wooden stand at the crusher. At right, from left to right, Lilly "Mary" Peters Altizer, Ginny Wooden, Betty Peters, and John Altizer hold finished bricks. John Altizer was employed at the North Mountain Brick Factory in 1951, when these photographs were taken. Today, the North Mountain Hunt Club occupies the site. (Both courtesy Mary Altizer.)

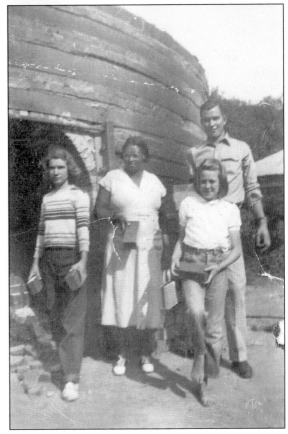

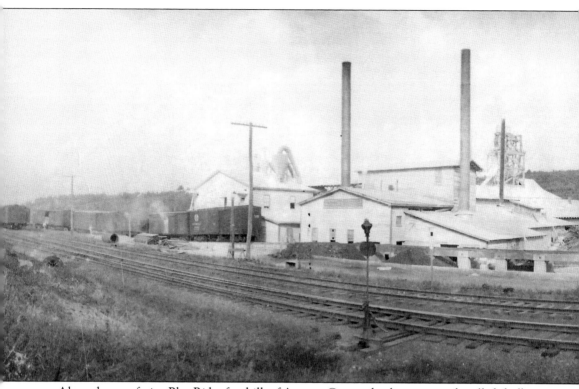

Along the west-facing Blue Ridge foothills of Augusta County, kaolin, commonly called chalk, was mined for about a century. Just east of Greenville, about one-third of the way up the mountain, large quantities were extracted and moved by cable car to this processing plant at the Cold Springs

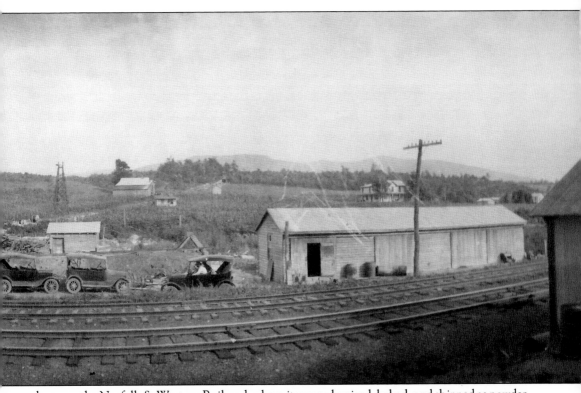

depot on the Norfolk & Western Railroad, where it was pulverized, baked, and shipped as powder to be used as paper filler and in china. This plant burned in the 1950s, causing the mine to cease operations. (Courtesy Elaine Moran.)

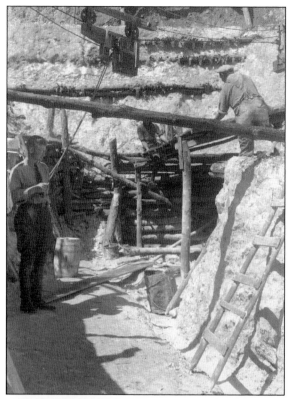

The Crimora Manganese Mine, located two miles east of the town of Crimora in the eastern part of the county along the foothills of the Blue Ridge Mountains, began operations in 1866 and continued until 1946. The open-pit mine—500 feet wide, 200 feet deep, and a half mile long—produced more manganese than any other single deposit in the United States and, at one time, the world. The deposit lay under a layer of clay and quartz and was a 15-foot-deep seam. Manganese is critical to steel production. All that remains of the mine today are three adjacent man-made lakes of varying depths up to 100 feet deep, which connect area water sources via underwater shafts. (Both courtesy ACHS.)

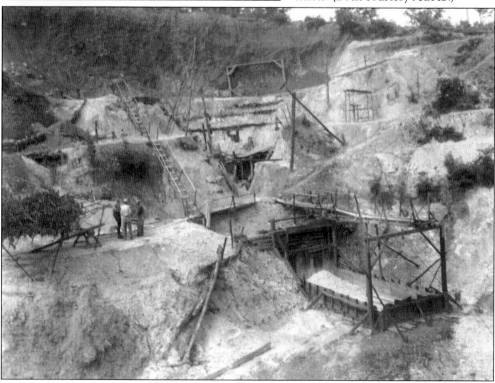

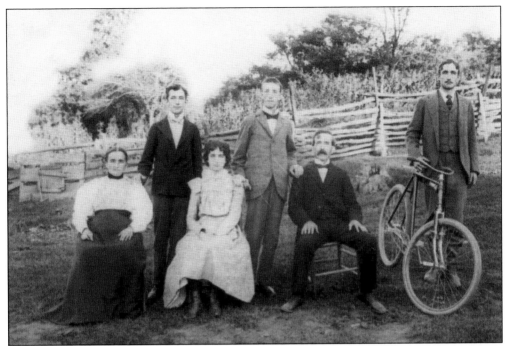

While life in the Stokesville area might have been remote compared to those who lived along the main valley corridor, it was certainly not backward. Here, the Frank J. Whalen family poses in their best outfits with a newfangled contraption called a bicycle. (Courtesy JMUDSA, Charles Cramer Collection.)

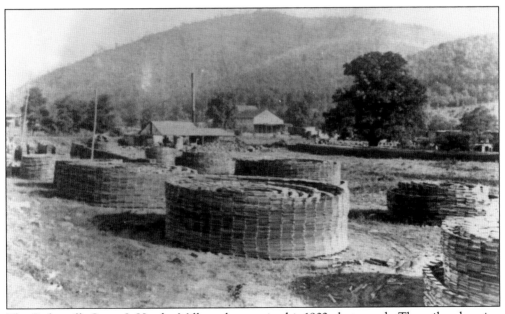

The Stokesville Stave & Header Mill can be seen in this 1902 photograph. The railroad engine house is in the left center and the Stiegle Lumber Company mill is in the center behind it. Several Stokesville industries, including this one, were based on timbering. (Courtesy JMUDSA, Riddleberger Collection.)

Craftsmen often practiced their trades in homes or small shops as cottage industries. Such was the case with Marvin S. Downs of Buttermilk Springs Road, just outside of Staunton. Downs made brooms, many of which are seen here hanging from the rafters in his small shop. (Courtesy Janet and Earl Downs.)

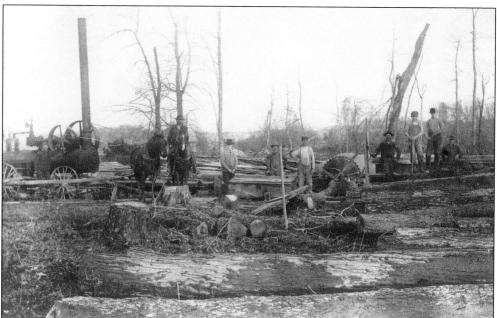

Many Stokesville industries were based on intensive timbering for lumber, staves, and tanneries. The industries quickly denuded the landscape, but, by the 1920s, the area had been purchased by the government and turned into a national forest with timber management controls. Originally called the Shenandoah National Forest, it eventually became known as the George Washington National Forest. (Courtesy ACHS.)

Eight

BUSINESSES AND BUILDINGS

Driven by the necessity of clearing land and planting a crop, Augusta's first settlers naturally lived in crude log huts, often with no windows, slabs of wood placed horizontally across the rough rafters for a roof, and chimneys made of wattle and daub. Within a few years, however, crude huts turned into nicely cut, carefully notched log dwellings, and substantial two-story structures arose. By the early 1800s, water-powered technology had advanced enough that machine-cut lumber could be easily produced. More prosperous farmers covered their log homes with weatherboarding.

Although wood always dominated county construction, the Scotch-Irish settlers came from a place where trees were scarce and stone was the chosen building material. By the late 1700s, many of those settlers, such as the Lewises and the Moffetts, were constructing nice houses of stone. Stone construction was often used for public buildings in the late 1700s as well, especially Presbyterian meetinghouses, where crude log structures were being replaced with more solid stone buildings. Augusta Stone, in Fort Defiance, and Old Providence, in Spottswood, both still have stone structures from that time.

By the early 1820s, brick became fashionable, especially if pockets of clay existed near a building site. Wooden forms were filled with clay dug out of the stream banks and then fired on site. The walls of these brick buildings were many feet thick, but only the outer layer exposed to the weather was hard-fired. Those outer bricks were often given a dark glaze and randomly interspersed on the front of the house to give it a fancier look. Although entire houses were often made of brick, and many log houses added brick kitchen wings, very few outbuildings were brick. In Augusta, only two brick barns remain, one on the Mish farm, west of Middlebrook, and one at Folly Farm, south of Staunton.

During the first years of settlement, businesses, churches, and residences were often under one roof. As the wilderness moved west and towns and villages sprang up, buildings were often designed for specialized purposes: schools and churches, of course, but also workshops, meeting places for organizations, and factories.

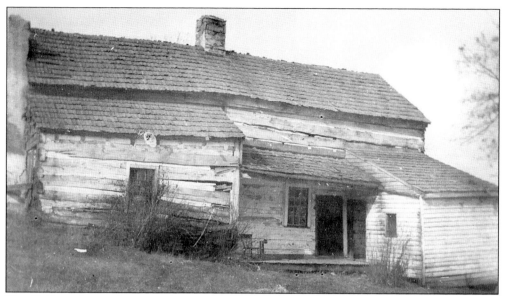

The Coffman home place, seen here, was located about half a mile northwest of Mount Sidney. Local amateur photographer and teacher Henry Clay Coffman was born in this house and took this photograph. (Courtesy ACHS, Coffman Collection.)

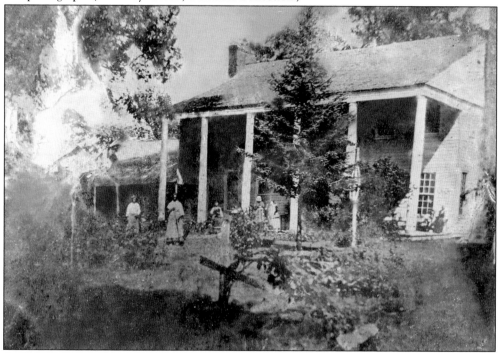

Oakland, a tavern located in the Deerfield Valley about 15 miles west of Staunton, was on the main wagon road to the resort springs in Bath County. This rare daguerreotype, taken before the Civil War, is the only known image of slaves in Augusta County. A surviving guest register reveals many famous travelers who stayed at the hotel, including Mexican general and president Antonio Lopez de Santa Anna and future Confederate general Thomas Jonathan "Stonewall" Jackson. (Courtesy Stonewall Jackson House, Virginia Military Institute Museums.)

The New Hope Telephone Company first organized as the New Hope Switchboard Association in 1902 after Charles R. Parr, the owner and operator of the first switchboard, ended service. Located in northeastern Augusta County, the company's goal was to own and control the switchboard and promote mutual exchange with other Augusta County switchboards. The service operated out of the H.C. Anthony house until 1921, when it moved into a five-room bungalow built to house the switchboard, the switchboard operator, and his or her family. The 1960s saw the end of party lines and the installation of an automated switching system that made operators like Edna Berber, seen here, a thing of the past. (Courtesy Owen Hanger.)

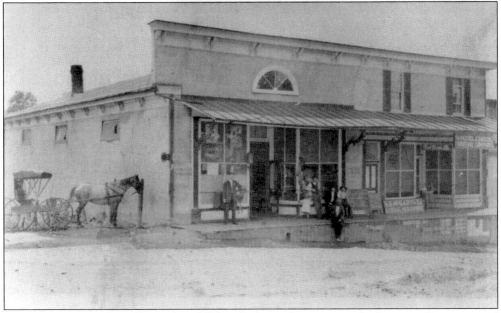

In the late 1800s, the village of Middlebrook, located on a turnpike between Staunton and Brownsburg (in Rockbridge County), was the largest and most prosperous community outside of Staunton itself. The general store seen here was just one of several in Middlebrook. Today, the entire village is in the National Register of Historic Places. (Courtesy ACHS, AC Collection.)

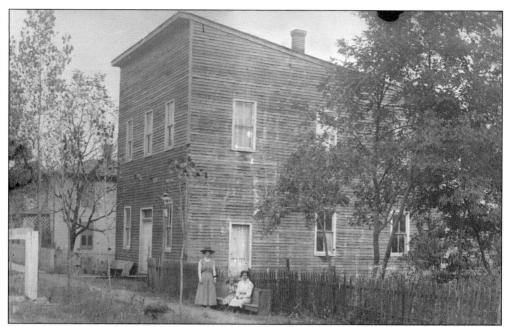

The Junior Order of United American Mechanics (JOUAM) built the Mount Sidney town hall around 1900. Community events took place on the first floor and the JOUAM met on the second. This organization sprang from the United American Mechanics, an 1845 nativist labor group that promoted American labor interests. The JOUAM evolved into a fraternal society and social club that offered beneficial life insurance reserve for its members. (Courtesy ACHS, Coffman Collection.)

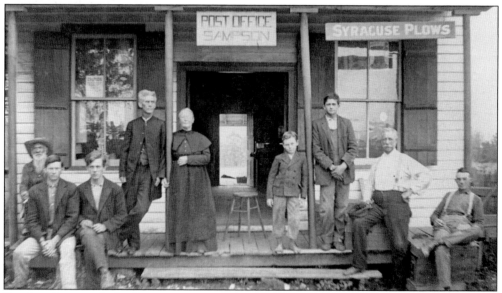

People gather outside the Sampson store and post office, located about two miles north of Crimora in the northeastern part of Augusta. The establishment was owned by the nearby Sampson family. Until well into the 1900s, most post offices were located in small country stores. While the business owners only received a small portion of postal revenue, the convenience created community gathering spots and brought customers. (Courtesy ACHS, Coffman Collection.)

Seawright Springs, seen here as a pool of lithia water, was located 10 miles north of Staunton and three miles west of Route 11. It began business operations in 1890 as a resort spring and expanded with the construction of a sanitarium and a hotel. The hotel was destroyed by fire in 1909, days before it was to open, and was never rebuilt. The addition of a swimming pool prolonged the life of Seawright Springs, as did a bottling plant, neither of which remain today. (Courtesy ACHS, Coffman Collection.)

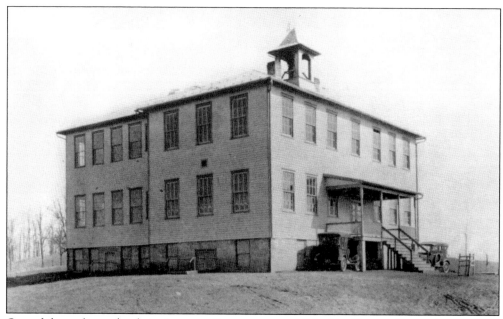

One of the earliest schools in Augusta County was established in Centerville, in the northern part of the county, in 1857. In 1913 and 1914, a much larger, two-story frame high school building was constructed, seen here when it was brand new. The school burned down in 1929 and the high school was moved to Harmony. (Courtesy ACHS, Coffman Collection.)

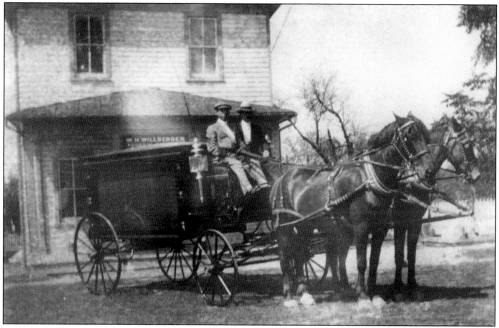

A horse-drawn hearse stands in front of the Willberger Funeral Home, in New Hope, in 1925. Willberger's was one of two funeral homes operating in northern Augusta County. Founded by William "Willie" Willberger in 1892, the business stayed in the family for nearly 90 years. The embalming room was located directly behind the first-floor front room that was used for services. Caskets were displayed on the second floor. (Courtesy Owen Hanger.)

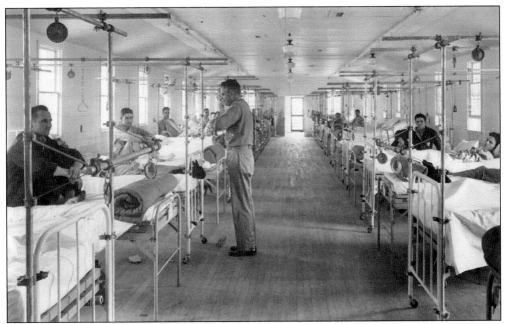

Woodrow Wilson Military Hospital, now the Woodrow Wilson Rehabilitation Center, was located on Route 250 in Fishersville. Built during World War II, the hospital opened its doors in time to serve 300 wounded soldiers from the North African campaign. It was built for 1,500 patients, but 2,000 eventually arrived. While providing a home for recuperating injured soldiers, the facility also laid the groundwork for rehabilitation and vocational retraining of maimed and wounded soldiers to return to productive civilian life. Housed on modern wards, soldiers benefited from therapy and equipment taken for granted today, such as wheelchair ramps and whirlpool baths developed at the hospital. The hospital's brick entranceway (below), which opened onto the main highway, was staffed with armed guards 24 hours a day. After the war, the hospital was closed and half of the facility was converted into the state-operated rehabilitation center. The other half became part of the Augusta County school system. (Above, courtesy Woodrow Wilson Rehabilitation Center Foundation; below, courtesy Bud Hoffman.)

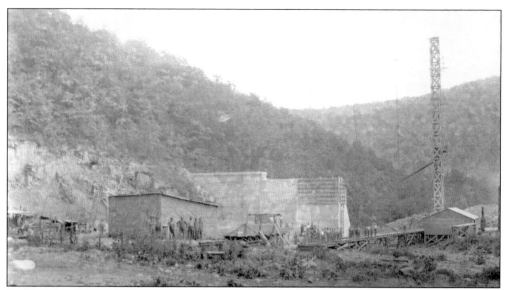

In the 1920s, Staunton was so desperate for a reliable water source that it decided to construct a dam and reservoir in the newly created national forest. Using mules, steam machinery, and manpower, a 100-foot-long, 40-foot-high cement dam was built on the North River between 1924 and 1926. Workers then dug a 6,000-foot tunnel through Lookout Mountain and laid 14 miles of pipe to bring water to Staunton. The system remains in use today. (Courtesy ACHS.)

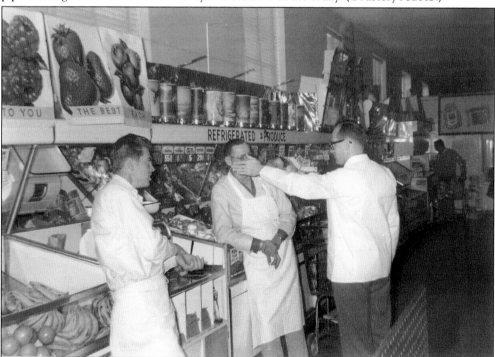

For rural Augusta County farm families, the Augusta County Cooperative Farm Bureau provided just about every service imaginable, from animal feed to clothing, farm implements, and even fresh groceries on a cooperative membership basis. Here, from left to right, Roger Shifflett, Jake Craun, and Bernard White talk in the produce section of the store. (Courtesy Janet and Earl Downs.)

Nine

GROUPS AND GATHERINGS

More often than not, people are social, not solitary, creatures. Even in the days when transportation relied on four-legged animals, people gathered as often as possible for occasions both happy and sad. Funerals often drew bigger crowds than weddings, but school and sporting events also brought communities together in friendly rivalries. Many times, the gatherings coincided with an official event such as Election Day or a cornerstone-laying ceremony.

Clubs and social groups provided another reason to gather for a purpose. Youth might gather for a 4-H Club or school club event, for instance. Churches also provided the opportunity for like-minded individuals to gather, especially if they were members in a choir or a band or were attending a church conference.

The gathering of community men to fight fires was a far more serious endeavor. Starting in the early 1900s, villages across the county such as Stuarts Draft, Churchville, Weyers Cave, New Hope, and Middlebrook began training men to respond to the threat of fire, which could occur in places where many wooden structures were close together and homes cooked and heated with coal or woodstoves. Having a fire department meant having to raise money, and that spawned yet another reason to gather, and lawn parties and carnivals served the dual purpose of fundraising and entertainment.

Remembering particular events in history might be a reason for a veterans' group to gather or for a group to remember a shared moment in history such as the Civil War Battle of Piedmont. Families often gathered at a special place to celebrate a particular occasion, such as the Arehearts, who traveled to Cold Springs Resort to celebrate their wedding anniversary. The Craun family gathering, also at a resort spring, this one at the other end of the county, was more bittersweet, as one of their group prepared to leave the Shenandoah Valley for Kansas. At other times, such as a picnic, no special occasion was needed, but the day afforded the opportunity to get outside and enjoy the friendship of others.

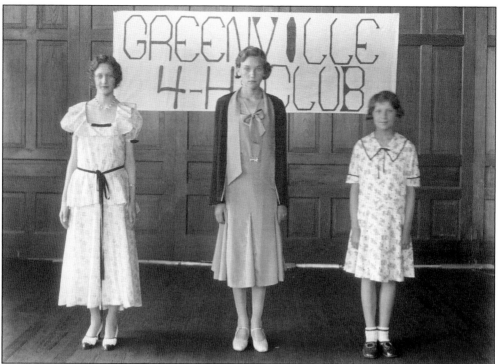

In the 1920s and 1930s, home demonstration agents focused on helping rural women and girls improve themselves. Clothing contests gained popularity with 4-H Club girls, who were judged on clothing selection and construction as well as grooming and posture. Winners of the Greenville 4-H Club Revue in 1931 included, from left to right, Ester Gayhard in the cotton party dress class, Hilda Harvey in the semi-tailored dress class, and Dorothy Vines in the school dress class. (Courtesy USDA photographer George Ackerman, May 15, 1931.)

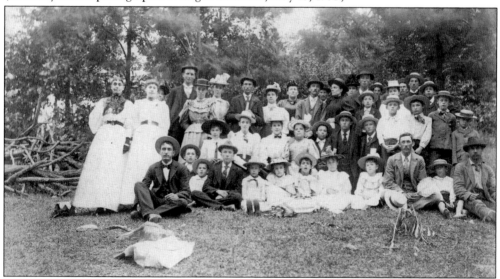

The handwritten notation on this photograph indicates that it shows a picnic in Stingy Hollow, just south of Staunton. It was likely a Sunday school gathering of some sort, as every person in the photograph is dressed up and wearing a nice hat. (Courtesy ACHS.)

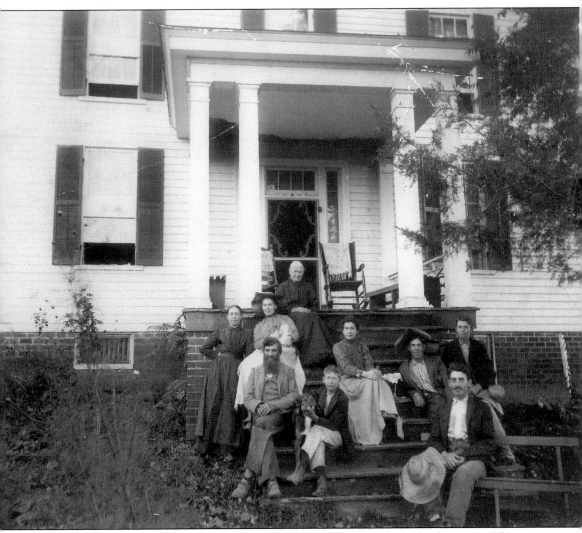

Dunker and pacifist Cornelius G. Shaver and his wife, Catherine, built this house in 1856 on their farm northeast of Piedmont. Union general David Hunter made it his headquarters in the Civil War Battle of Piedmont on June 5, 1864. General Hunter directed the battle from the front porch and the porch roof while the family took refuge in the basement kitchen. Hunter's victory secured Union control of the southern Shenandoah Valley. Catherine Shaver is seated on the top row of this 1890s photograph. (Courtesy Owen Harner.)

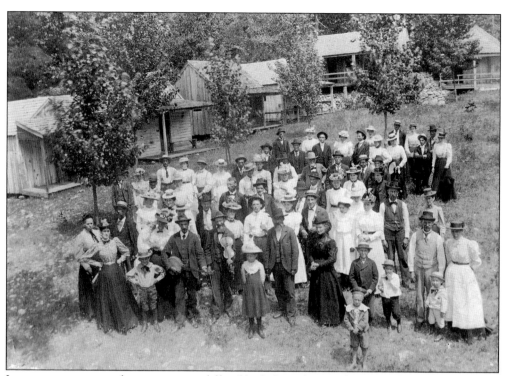

In many respects, people a century ago differed little from those today in enjoying an escape from everyday life. For the Arehart family, Cold Springs Resort provided the perfect venue. The springs, located in what is now Big Levels in the George Washington National Forest, on the slopes of the Blue Ridge Mountains east of Greenville, attracted visitors wishing to escape the heat and humidity of the valley floor. Rustic cabins and a camping atmosphere provided a place to play music, dance, and socialize. Visitors could also dip in the cool spring waters. Above, on Sunday, April 23, 1899, family and friends gathered at the resort to celebrate the 25th wedding anniversary of George Christian Beard Arehart and Sarah Elizabeth Swisher Arehart. The photograph below shows guests surrounding the actual spring. (Both courtesy William Arlen Hanger.)

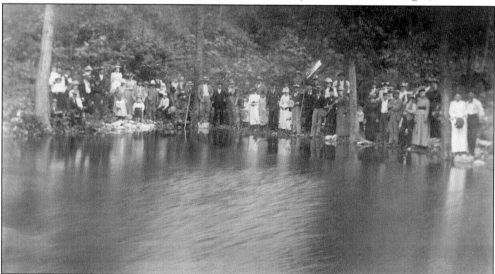

This group of local leaders gathered at the Newport School on Election Day in 1940. From left to right are Bud McCutcheon, David H. McCray, Arthur Miller, Dave Ott, and Bill Beard. (Courtesy Harry R. McCray.)

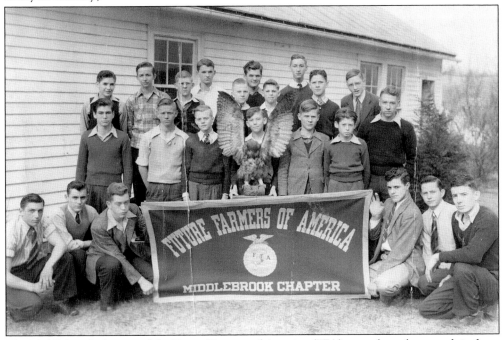

The Middlebrook chapter of the Future Farmers of America (FFA) poses for a photograph in front of Middlebrook High School's agriculture building. Although the school is long closed, the building more recently served as a doctor's office. Individuals identified in this image are, in no particular order, Dallas Hemp, Sydney Berry, Wayne Shultz, Bob Heiser, Bobby McCray, Jimmy Hutchens, Charlie McCray, Jack Root, Tommy Stephenson, Tommy Arehart, Fred Cason, and Frank Decker. The first FFA chapter in America was started in Weyers Cave. (Courtesy Harry R. McCray.)

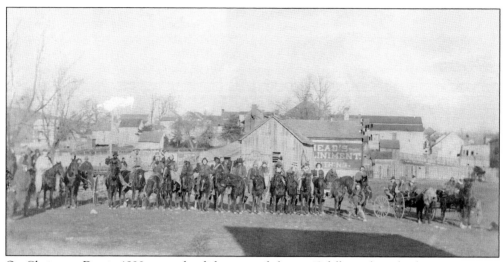

On Christmas Day in 1899, an outlandish group of almost 40 folks on horseback or in carriages spread out across the road in Middlebrook, ready to raise a ruckus. These Shanghaiers were participating in a Christmas tradition noted in many places across Augusta County in which merrymakers wearing costumes, hats, and masks formed an unruly and boisterous group that paraded through town streets. (Courtesy Gary Rosen.)

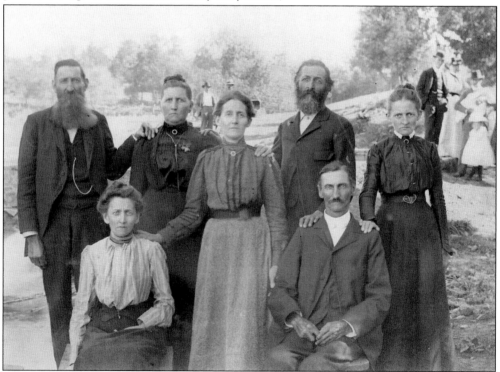

A late-1800s Craun family gathering at Seawright Springs provided a bittersweet opportunity for a photograph before John Craun departed for Kansas. Seen here are, from left to right, (seated) Emma Craun Houff and C.E. Granville Craun; (standing) John William Craun, Ellen Craun Jordan, Eddie Craun Ruff, George S.E. Craun, and Alice Craun Houff. (Courtesy ACHS, Coffman Collection.)

Above, four young girls pose next to their winter work of art after a 1922 snowstorm, while, below, that same snowstorm gave the neighborhood boys an opportunity for some snowball throwing. (Both courtesy ACHS, AC Collection.)

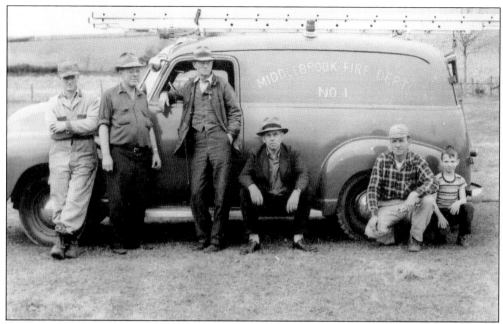

Established in 1949, the Middlebrook Volunteer Fire Department began with 11 members, including Oser Beard as the first chief. Initially, the company fought fires using a two-wheeled tank pulled by two men and also drove a panel truck with a portable pump, a fire hose, and a ladder. Members of the Middlebrook crew are seen here posing in front of their vehicle in 1949. They are, from left to right, Walter McCray, Charlie Almarode, Sam McLaughlin (a one-time Augusta County supervisor), Frank Smiley, Henry Potter, and Junior Potter. (Courtesy Bill Brubeck.)

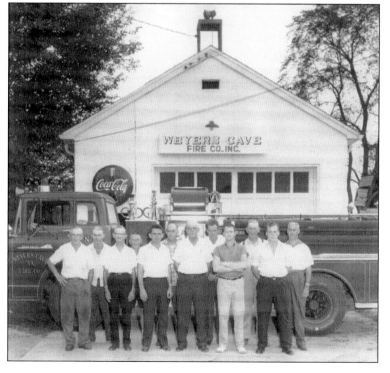

The Weyers Cave Fire Company became the county's first organized station in 1924. After a series of large fires struck the area, it purchased several chemical tanks and stationed them within the village. In 1948, the company was chartered with 73 members and constructed a firehouse for $2,300. Operating under the motto "First in, last out," the company is still 100-percent volunteer today. (Courtesy Weyers Cave Fire Company.)

Ten

GAMES AND GOOD TIMES

Life was not all work and no play, even 100 years ago. Just as with every society, people found ways to relax and enjoy their lives. For those with a little extra spending money, that meant going to the many resort springs that dotted the area, such as Stribling Springs, Seawright Springs, Augusta Springs, and Cold Springs. There, visitors could bathe or drink the waters that were often touted as having health-restoring qualities. People listened to music from the official resort bands at the springs or brought their own instruments to a gathering.

Getting out and communing with nature was also as popular then as it is now. People took wagons and carriages on sightseeing excursions to experience natural geological wonders such as Grand Caverns and Natural Chimneys. Such places were often the scenes for balls and picnics, and, at Natural Chimneys, riders tested their horsemanship in jousting tournaments. Just as today, children got out and played in the farmyard during the summer. Young men traveled the roads as boisterous youths and explored activities probably frowned upon by their elders, such as card playing.

Community gatherings through churches and schools were often the setting for photographs and memories of a more organized sort. School plays and ball games were occasions to gather and support the local talent. Almost every tiny hamlet had its own baseball team, while a few schools and communities were also exploring the newfangled games of basketball and football by the early 1900s.

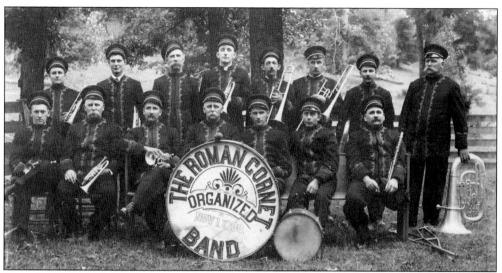

This photograph of the Roman Coronet Organized Band, from Roman, a small community between Route 11 and Spring Hill, illustrates the vitality of Augusta County's rural culture. The band included, from left to right, (first row) Tad Dunlap, Dave Rimel, Dave Good, Charles Rimel, Hockman Misner, John Alexander, and Bill Good; (second row) Newton Good, George Brown, John Rimel, Frank Simmons, Otto Sheets, Trene Crone, George Good (director), and Bill Rimel. (Courtesy ACHS, Coffman Collection.)

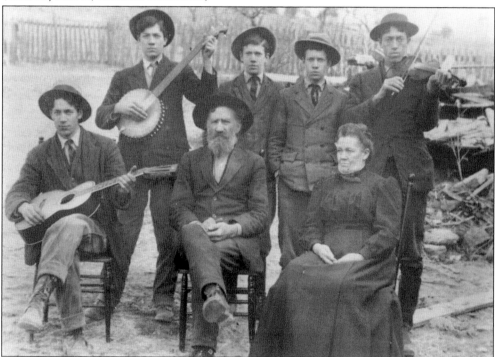

The Lucas family of Dutch Hollow, in southern Augusta, evidently had a musical bent as well, as can be seen in this 1910 photograph. From left to right are (seated) Scott, on the guitar, and parents Samuel Stuart Lucas and Mary Lucas; (standing) Roy, on the banjo, twins Floyd and Homer, and Ernest, on the fiddle. (Courtesy Kimberly Lucas Berry.)

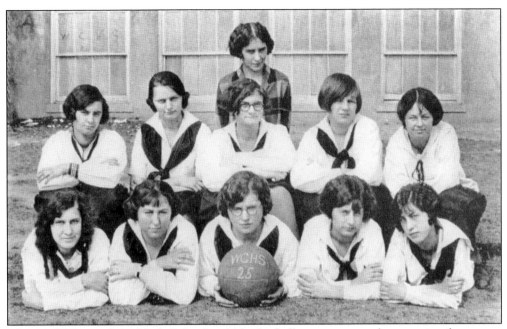

The 1925 Weyers Cave High School girls' basketball team is seen above posing for a team photograph. (Courtesy ACHS, AC Collection.)

"Who are we? Can you guess? The football team of VHS!" is the inscription on the back of this Valley High School football team photograph, taken in the 1890s. The private high school operated under the auspices of Old Providence Associate Reformed Presbyterian Church in Spottswood. (Courtesy Old Providence ARP Church.)

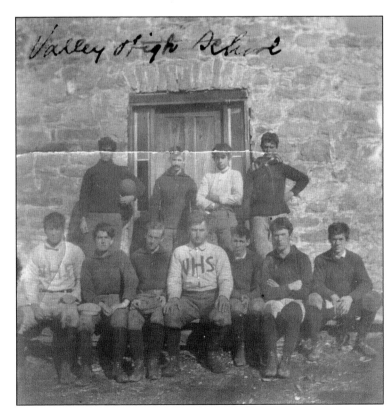

Natural Chimneys, located near Mount Solon along the North River, features solid rock limestone formations that stand 120 feet above the valley floor. They stand in mute testimony to the geological forces that shaped the Shenandoah Valley. Once a vast Paleozoic inland sea, limestone accumulated and hardened over time. Subsequent geological upheaval and water erosion undermined the softer rock, leaving only the "chimneys." Today, a 145-acre county park on the site provides recreational opportunities to visitors. (Courtesy Virginia Davis.)

Natural Chimneys Park is also home to the National Jousting Hall of Fame and hosts an annual jousting tournament, reputed to be the oldest continuous sporting event in the country. In the minds of early-19th-century Augustans, the limestone chimneys resembled medieval castle towers, therefore providing the perfect setting for jousting tournaments that tested riding skills. Competitors rode as knights and ladies and the tournaments were followed by grand balls. Here, champion jouster Earl Wampler competes in a tournament at Natural Chimneys while his children (right foreground, from left to right) Earl Jr., Betty, and David Wampler watch. (Courtesy Owen Harner.)

Four young people relax on a Sunday outing near Mossy Creek Lake on August 29, 1909. The northern Augusta County lake was created when the creek was dammed off in order to direct water to a large feed mill. The area also contained a paper manufacturing site, a sawmill, and an ironworks. The lake no longer exists, and the mill was shut down in 1949 after a thunderstorm and subsequent flood destroyed the dam. (Courtesy ACHS.)

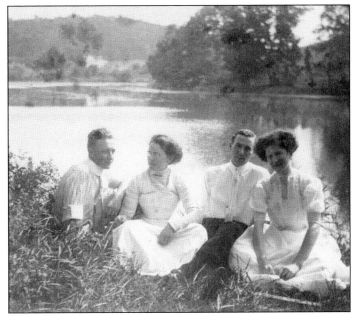

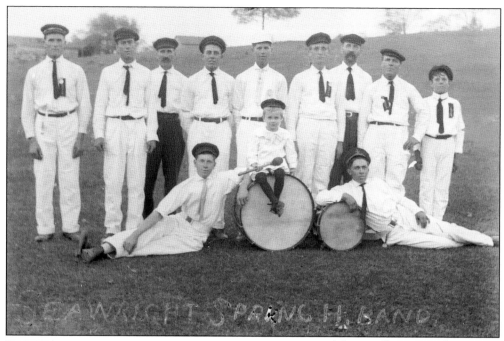

SEAWRIGHT SPRING H. BAND.

Most small towns and communities had a band of some sort. The resort at Seawright Springs was no different, except for the fact that Henry Clay Coffman lived nearby, so, by default, this band (above) in all its variations was the most photographed band in the county. (Courtesy ACHS, Coffman Collection.)

Instead of leafing through bridal magazines, young ladies of an earlier era sometimes staged pretend weddings, such as the one that Callie Pernie (Clemmer) Reed (left) and Eva Craig did in rural southern Augusta County. In the days before computers, televisions, and even radios, the imagination was the best way to have fun and get a small break from the drudgery of farm life. (Courtesy ACHS, AC Collection.)

Nancy Gertrude Griffith gathers daisies while on a date with her future husband, John Taylor, in 1925 in a field near Buffalo Gap, in the western part of the county. She lived in Staunton and they were traveling out into the countryside for a picnic, an activity popular among young people of the time. (Courtesy Nancy Sorrells.)

Below, the Hanger family poses beside their vehicle after a successful day of hunting, as can be seen by the lady on the far left holding a ruffed grouse. (Courtesy ACHS.)

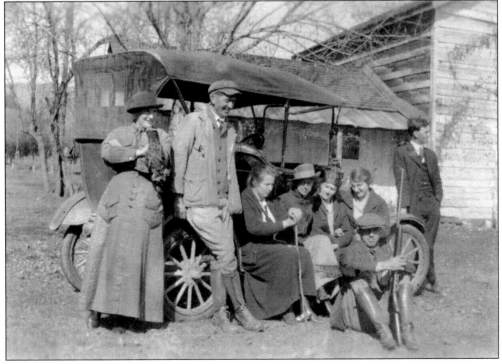

A playful pony grabs Dick Furr's hat as his brother Ed (second from left) and friends watch. Note the knickers and high socks the boys are wearing. Only adults wore long pants in the early 1900s. The boys are in a Greenville barnyard near the Furr mill. The house in the background stood above the mill. Although it had to be repaired after being washed out in a storm, the house still stands today. (Courtesy Chris Furr.)

Floyd Furr (left) and a friend smoke, relax, and play cards in the grass outside a small outbuilding around 1900. Someone in Furr's crowd enjoyed amateur photography, and the group of young men produced a number of photographs of themselves out posing and having fun along the byways of Augusta County. (Courtesy Chris Furr.)